GILLINGHAM & AROUND

THROUGH TIME

John Clancy

AMBERLEY PUBLISHING

First published 2014

Amberley Publishing
The Hill, Stroud, Gloucestershire, GL5 4EP
www.amberley-books.com

Copyright © John Clancy, 2014

The right of John Clancy to be identified as the Author
of this work has been asserted in accordance with the
Copyrights, Designs and Patents Act 1988.

ISBN 978 1 4456 2288 0 (print)
ISBN 978 1 4456 2302 3 (ebook)

British Library Cataloguing in Publication Data.
A catalogue record for this book is available from the
British Library.

Typesetting by Amberley Publishing.
Printed in Great Britain.

Introduction

There are three towns in Britain that are named Gillingham: one is in Dorset, another is in Norfolk, but the one whose story I shall be unravelling here is in Kent.

My association with Gillingham began in the mid-1960s when we moved there after getting married. At the time, my wife was a librarian at Gillingham library, while I was a clerk at County Hall, Maidstone. A deciding factor in setting up home in Gillingham for me was that transport links from Gillingham to Maidstone were far better than those from our hometown, Sittingbourne. In the early 1970s, I was offered a job with Gillingham Borough Council, so there we stayed until 1997 when, having taken early retirement four years earlier, we decided to move back to Sittingbourne. Gillingham had long been seen as the nicer of the Medway Towns. It had some good stores like Marks & Spencer, Littlewoods and Lefevre's, and it is a childhood memory that in the years following the Second World War my mum and aunt always went there to do their Christmas shopping. By the time we left in 1997, the town had rapidly deteriorated.

Many towns convey an air of permanence, of having been where they are since time immemorial, but this is not always so. Look carefully at the buildings in Gillingham High Street and its side roads, and what becomes apparent is that none of them are of any great age. This is because, in the nineteenth century, most of what is now regarded as Gillingham was, in fact, open land known as New Brompton, an area that was ripe for development. Throughout the eighteenth and nineteenth centuries, the dockyard steadily grew in size, needing more and more workers. Many set up home in Brompton, just outside the dockyard gates, but opportunities for expansion here were limited; it was hemmed in by the dockyard, the Army barracks and the Great Lines, a military encampment and training ground. The only opportunity for expansion was the open land to the east of the

Great Lines. This housing boom was centred on what today is the High Street and it radiated out in all directions. A grid pattern of streets and roads was laid out, and hundreds of small terraced houses were built. The progress of this development can be seen in the changes in house design and, of course, the date stones set into many terraces.

At the far end of the High Street is the railway station, which was opened on 25 January 1858 and was originally known as 'New Brompton and Gillingham'. The line was part of the East Kent Railway's first operational stretch between Faversham and Chatham. From the outset, the name boards clearly stated this was 'New Brompton', but in 1886, the station became known as 'New Brompton (Gillingham)'. Eventually, on 1 January 1899, the South Eastern & Chatham Railway renamed the station 'Gillingham'.

Gillingham itself was originally just a small hamlet located around St Mary's church at Gillingham Green, overlooking the River Medway and an ancient trackway that ran right across Kent, now known as the Lower Road. It stands just over half a mile away from the High Street. The church is the oldest building in Gillingham. There was also an Archbishops' Palace nearby, built by Odo, Bishop of Bayeux, following the Norman Conquest. Odo was also responsible for building the parish church. By the fourteenth century, Gillingham had achieved considerable prominence, and was granted royal permission to hold an annual fair and weekly market. As time went by and the area became more densely populated, brought about largely by the Victorian expansion of the dockyard, Gillingham grew to encompass places like Brompton, Grange and Twydall.

Later, communities developed along Watling Street, the turnpike linking Chatham with Dover, and eventually all these communities merged into the town that is today called Gillingham. In the 1891 census returns its population was 27,809, but by 1901 it had grown to 42,530. Gillingham became an urban district under the Local Government Act of 1894, gaining municipal borough status in 1903 when John Robert Featherby was elected as the first mayor of the new Borough of Gillingham. He is commemorated in the naming of Featherby Road.

One of Gillingham's claims to fame is that it is the only town in Kent to have a football team playing League football. The club was first elected to the Football League in 1920 as members of the new Football League Third Division (South) but was voted out of the League in 1938, only to be re-elected when the league expanded in 1950. Since this time it has led an up-and-down existence. The club's roots are interesting. It began with the success of a local junior football team, Chatham Excelsior FC, which encouraged a group of businessmen to meet at the Napier Arms pub on 18 May 1893 with a view to creating a football club that could compete in

larger competitions. To do this, the club required an enclosed playing field where an admission fee could be charged, which at the time Excelsior lacked. They formed New Brompton FC, incorporating a number of Excelsior players. The gentlemen also purchased a plot of land, later named Priestfield Stadium, where they laid out a pitch and constructed a pavilion. New Brompton's first team played their inaugural match on 2 September 1893.

For many years, the main source of employment in Gillingham was the dockyard, two-thirds of which lay within the boundaries of Gillingham; when it ceased to be a Naval base in 1984, it created significant unemployment. Since the 1980s, however, Gillingham has rebuilt its economic base and the Gillingham Business Park was set up 3 miles (4.8 km) from the town centre to attract investments and diversify economic activity. The business park is now one of the most popular business locations in North Kent, being close to the M2 motorway.

In 1928, Rainham was added to Gillingham Borough. This town is unique in that it is the only one of the Medway Towns that was more or less unaffected by the growth of the dockyard. From being a relatively small community at the beginning of the nineteenth century, Rainham saw a considerable expansion in the twentieth century. From a rural community with an agrarian-based economy, Rainham exploited Gillingham's building boom by producing much of the bricks and cement required from its brickfields and cement works. In 1959, the railway line running through Rainham was electrified, thus cutting the journey time for London-bound commuters considerably, and Rainham became a popular place in which to live. Most of its housing therefore dates to more recent times; typical of this is the Parkwood estate off Maidstone Road.

Today, Gillingham can proudly look back at how it has grown and developed from a small riverside hamlet of just a few dozen fisherfolk to a district that has engulfed many other small villages and hamlets with a population of just under 100,000.

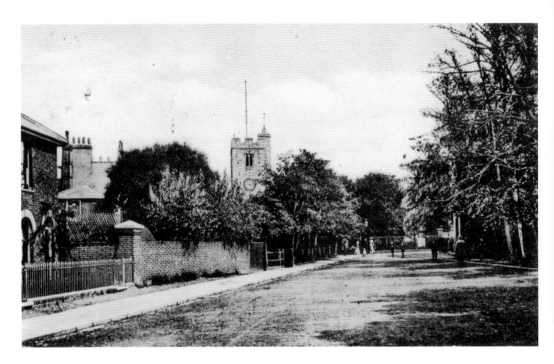

Gillingham Green

Gillingham's parish church, around which the original settlement stood, is dedicated to St Mary Magdalene and dates back to the twelfth century. It stands on the top of the hill overlooking the River Medway and is the oldest building in Gillingham. This early view dates to 1904 but, as can be seen, there have been few changes since then. The open square in front of the lychgate was no doubt where the early market was held.

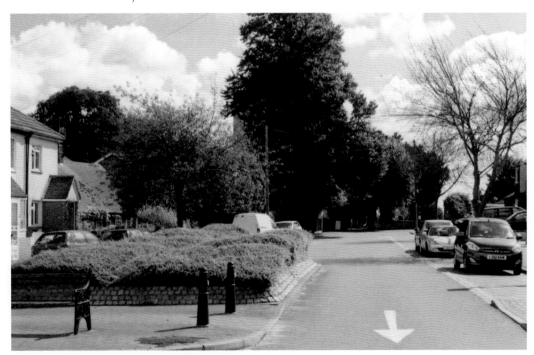

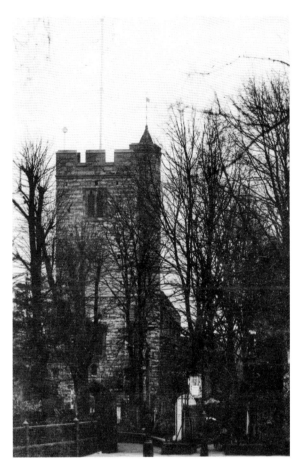

St Mary Magdalene Church
In this 1923 view the trees surrounding the church had already started to reach maturity but a more open vista was still possible. Today, the trees have grown to give a shady walk across the Green from Grange Road to Church Street, a walk I have taken many times.

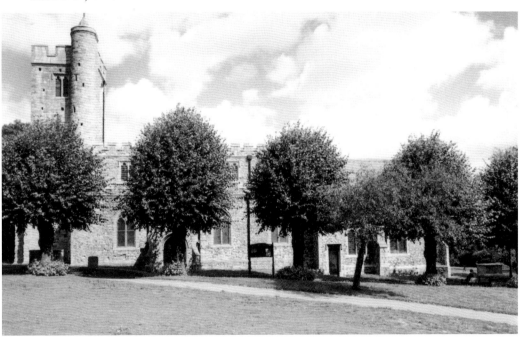

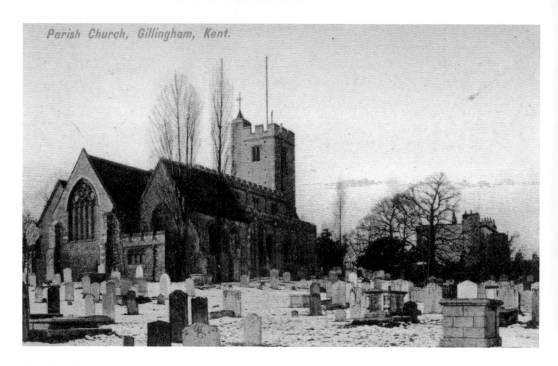

Parish Church, Gillingham, Kent.

The Church's North Face

Taken from the northern side of the church, this wintry view is almost timeless. From this viewpoint it can be seen that the top of the tower was an ideal place for the river's navigation beacon. It would have been visible for miles around. Today, many of the gravestones have been moved aside to give an open green space where the church held an annual fundraising fête for many years.

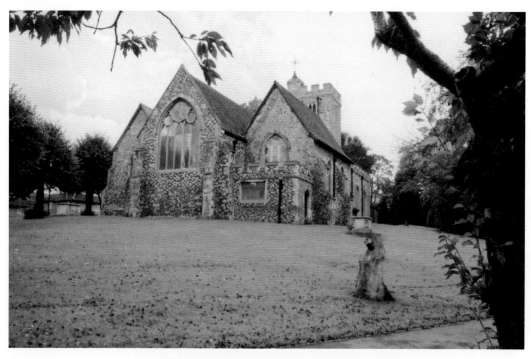

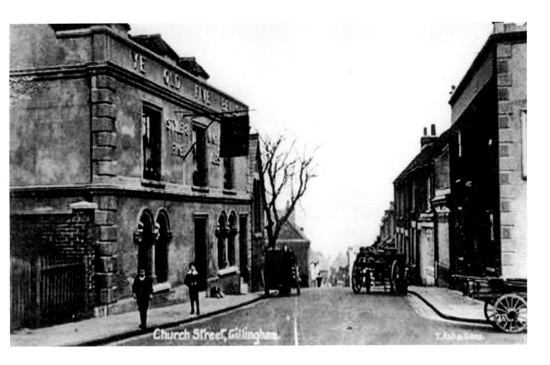

Church Street, Gillingham.

The Five Bells

Once the epicentre of old Gillingham, the Five Bells inn stands on the brow of the hill in Church Street and is believed to have been built in 1700. The parked carts and dress of the boys standing outside the inn suggest this fine old photograph was taken in the early 1900s. In the eighteenth century, this inn was known as the Five Bells and Cricketers, a name which is echoed in 1901 when it is referred to as Ye Olde Five Bells and Cricket Player's Inn. These names suggest it may have been popular with cricket players after a game on the nearby green. Like many pubs today, it closed down sometime before 2007 and was converted into flats.

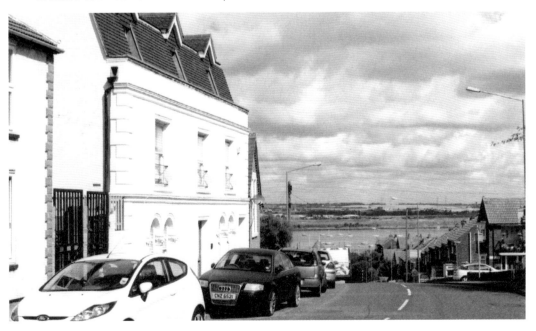

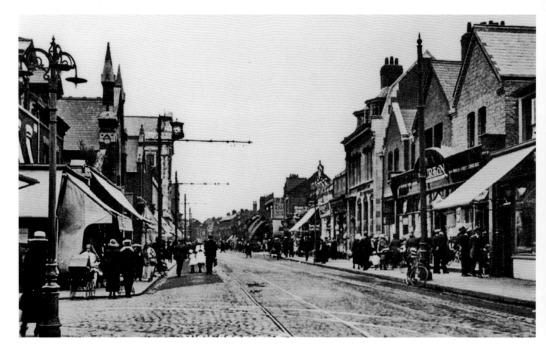

The High Street
An undated view of the High Street looking westwards towards the railway station. With the tram tracks and overhead power line still in place, this view could have been taken in the 1920s. The last tram ran in Medway on 30 September 1930.

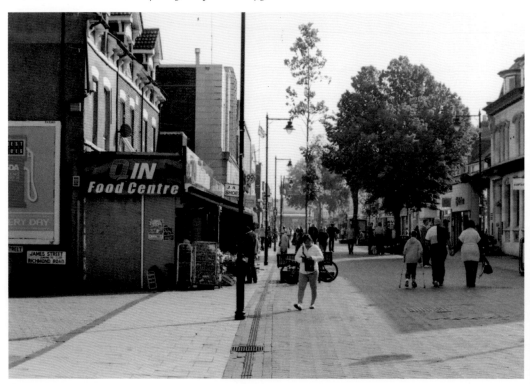

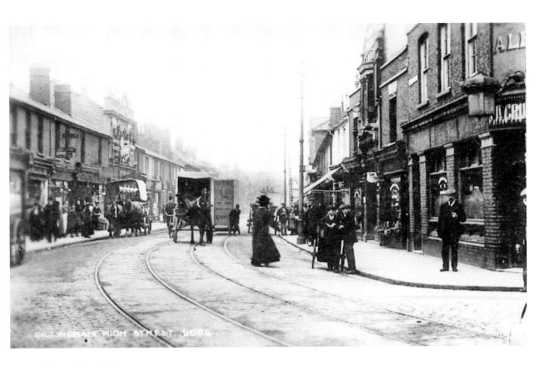

The Early High Street

One of the earliest views of the High Street I could find is thought to be of the corner of the High Street with Victoria Street. The tram tracks and overhead power line are in place and, together with the ladies' long dresses, this must date it to the early 1900s. The tram service was inaugurated in June 1902.

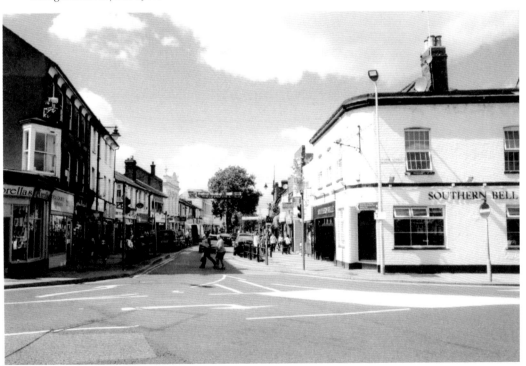

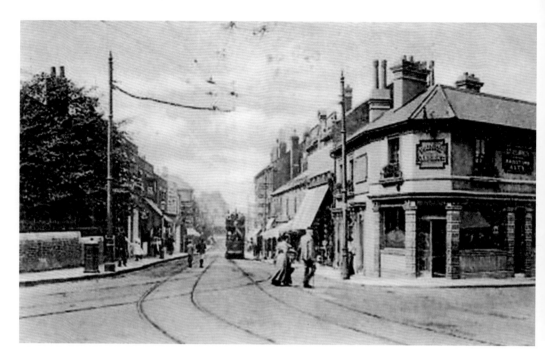

The High Street

Trams ruled the road in late Edwardian Britain. It was a new and exciting means of urban transport that conveyed large numbers of people at previously unimagined speeds. Picture postcard photographers were fascinated by them. Such is the antiquity of this 1908 view of the High Street looking eastwards towards Brompton that it is described as 'High Street, New Brompton'. It was not until 1899 that the railway station became officially known as Gillingham.

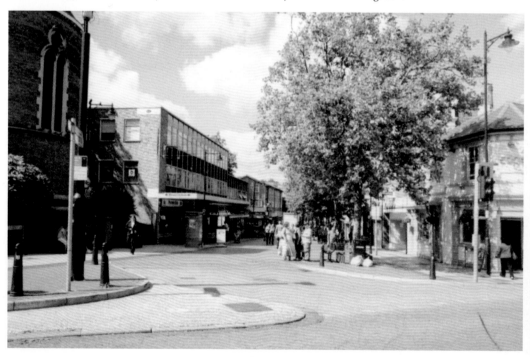

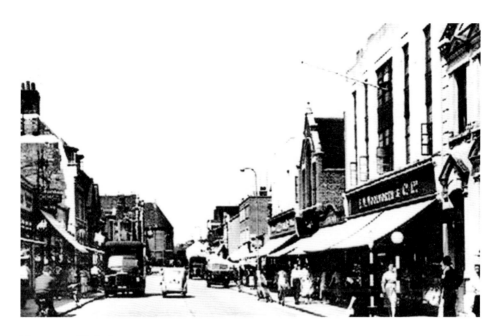

The 1950s High Street
Gillingham High Street peaked as a shopping centre in the 1950s/early 1960s. It had a good range of quality shops like Marks & Spencer, LeFevre's (later becoming Debenhams) and Littlewoods, but a combination of events, like the building of the out-of-town shopping centre at Hempstead and the pedestrianisation of the High Street, caused the closure of the larger stores.

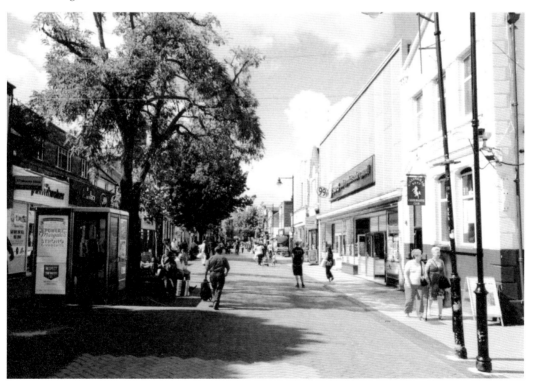

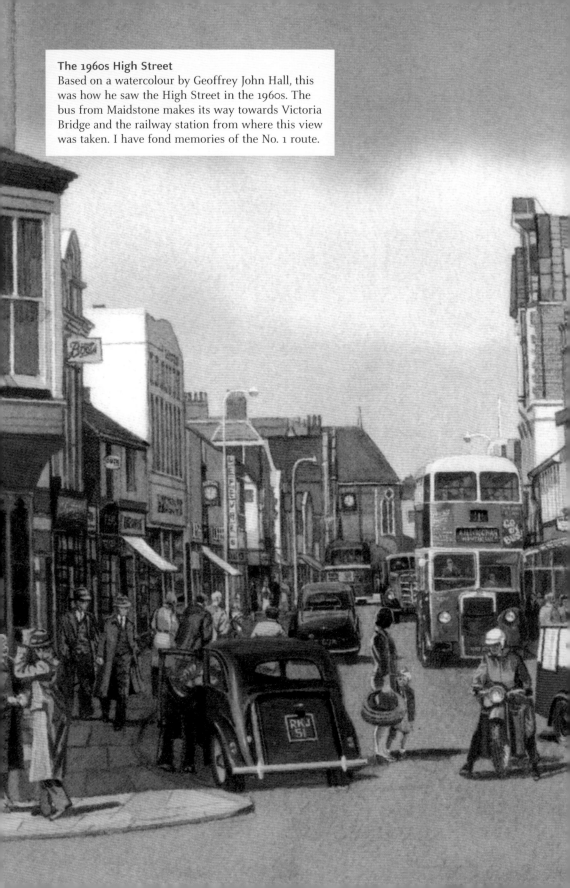

The 1960s High Street
Based on a watercolour by Geoffrey John Hall, this was how he saw the High Street in the 1960s. The bus from Maidstone makes its way towards Victoria Bridge and the railway station from where this view was taken. I have fond memories of the No. 1 route.

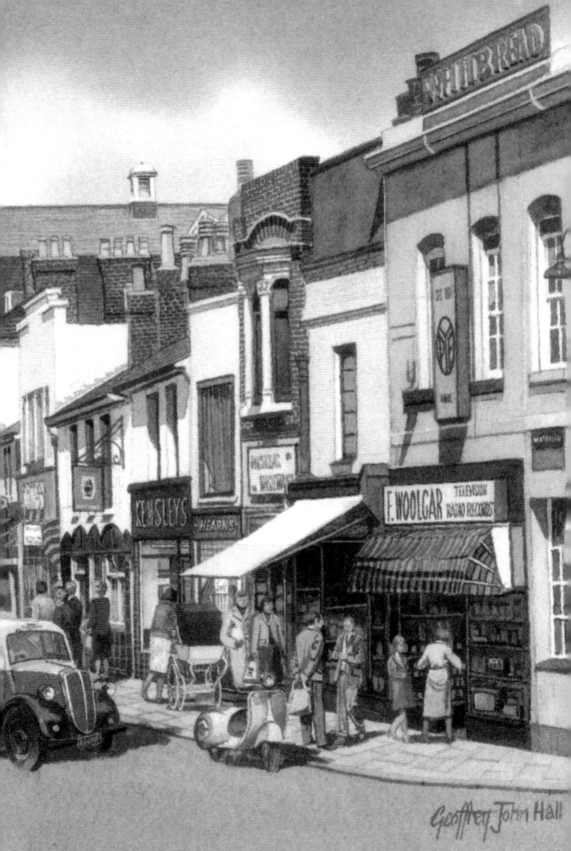

Geoffrey John Hall

LeFevre's and Marks & Spencer

Two of the shops that made Gillingham the shopping centre it once was. However, it should be remembered that Marks was not always the grand store it later became. Here it can be seen in the early part of its life in 1920, when it was a penny bazaar.

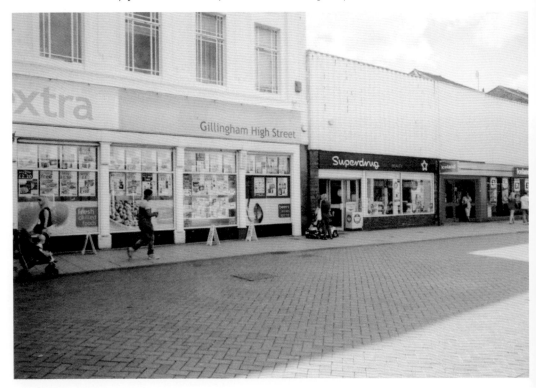

The Old Iron Ship

The Old Iron Ship was one of several pubs that were situated in the High Street. It stood close to the corner of Saxton Street and opened in 1862, probably as 'The Iron Ship'. It seems the 'Old' was added by common usage to distinguish it from the nearby (and, ironically, older) 'New Iron Ship'. It closed and was demolished in the 1960s when the High Street was widened. Today the site is occupied by a bland and unphotogenic row of shops, so by way of a contrast I offer a picture of The Britannia, the last remaining High Street pub.

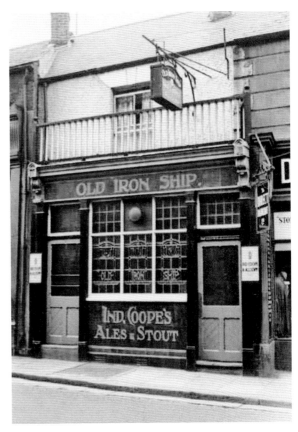

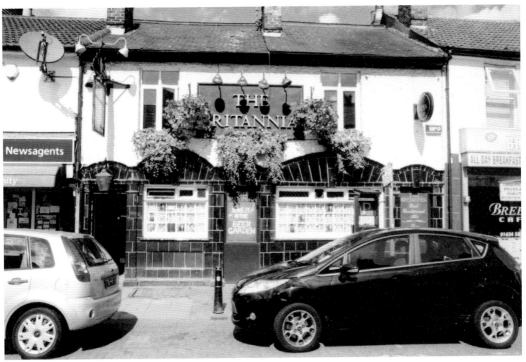

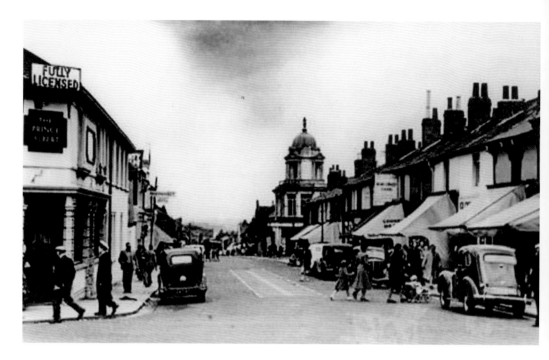

Skinner Street

Skinner Street is a side road leading off the High Street and is essentially an extension of Canterbury Street. Many of today's shops there were at that time terraced private houses, typical of the many there are to be seen throughout Gillingham. Dominating this 1950s streetscape is the lofty dome of the Grand Variety and Picture Theatre, which was demolished in 1965. It had been a popular entertainment venue since 1910.

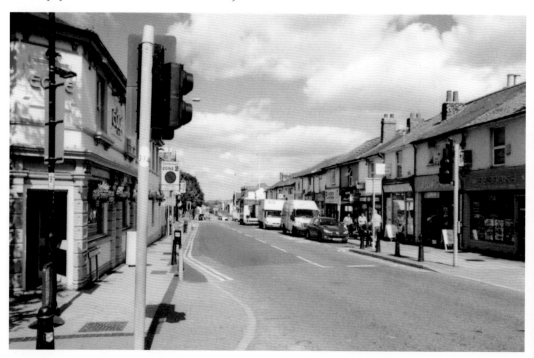

The Grand Variety and Picture Theatre

Opened on 26 November 1910, this theatre, standing on the corner of Skinner Street and Jeffery Street, was the largest one the people of Gillingham had ever seen before, with seating for 800. It was originally going to be called The Empire but, as there was already a theatre of that name in neighbouring Chatham, it was instead called The Grand – and grand it was in every respect. As was the vogue in Medway at that time, the entertainment was centred on variety acts. However, in 1914 the theatre closed, was sold and, after refurbishment, reopened as a totally dedicated cinema. It was a popular venue and continued to be so until 12 November 1960, when ever-dwindling audiences forced its closure. After standing empty for five years, the theatre was demolished in 1965 and today the site is occupied by Kwik-Fit.

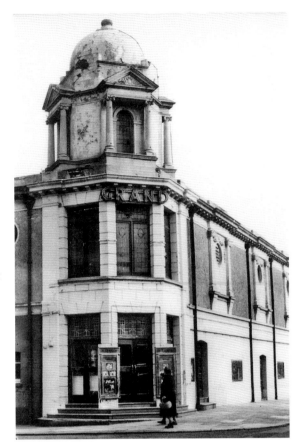

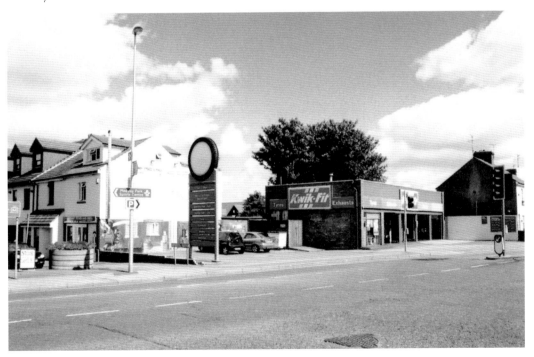

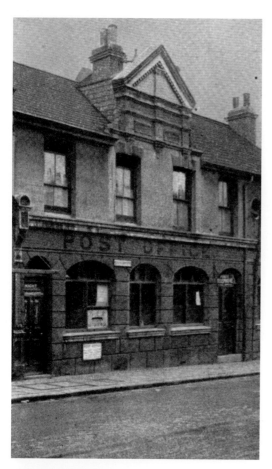

The Post Office

Many of those who know Gillingham will know that its post office is in Green Street, but how many know that originally it was in Skinner Street? Today it is a café, but if you could see behind the signage you would see 'Post Office' engraved above the windows. This is a view taken in its heyday just before the First World War, when it was only a branch office under the control of Rochester and Chatham.

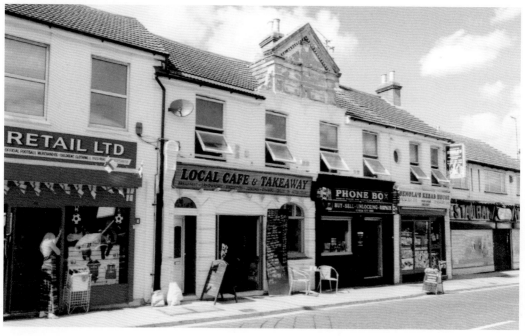

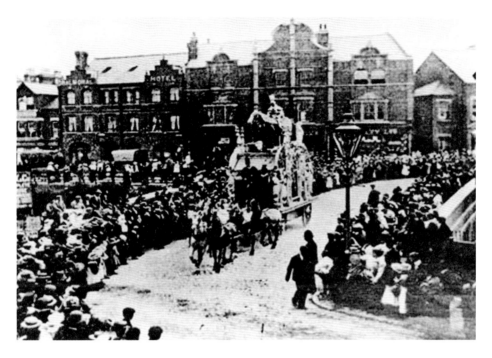

Victoria Bridge

The eastern end of the High Street is demarked by the railway station and Victoria Bridge. This is how the bridge looked around 1900 before the station was built. Only the buildings in Balmoral Road in the background are recognisable.

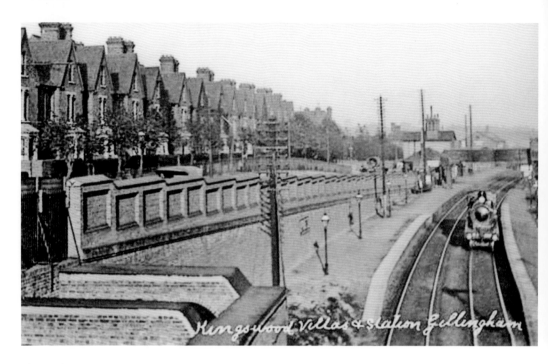

Kingswood Villas & Station Gillingham

The Railway Station

The entrance and ticket hall of the railway station was not originally situated where it is today. It was further down the line, opposite Kingswood Road. Today's station on Victoria Bridge was built in the 1920s and modernised in 2010.

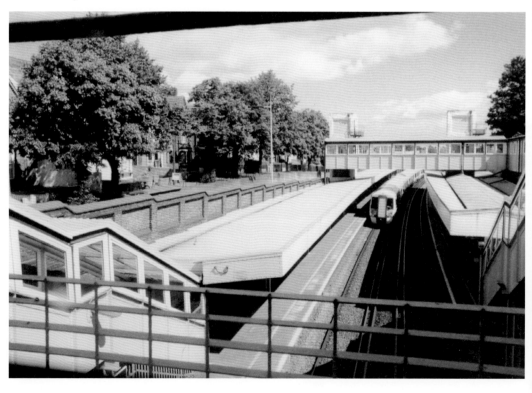

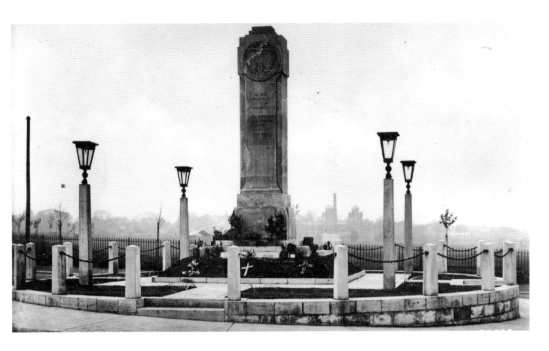

The War Memorial

The western end of the High Street is demarked by the town's war memorial, initially built to commemorate Gillingham's First World War losses. It was unveiled by Alderman W. H. Griffin JP and dedicated by Revd J. Harmer, Bishop of Rochester, on 20 July 1924. For many years it stood where the High Street converges with Mill Road, Brompton Road and Marlborough Road, and although it originally stood on a roundabout formed by these roads, it was later moved across the road to Medway Park, formerly the Black Lion Sports Centre. The area around the memorial has been refurbished and recently two inscribed plinths have been placed either side, behind the war memorial.

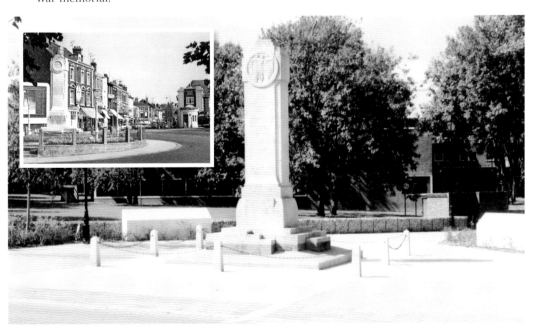

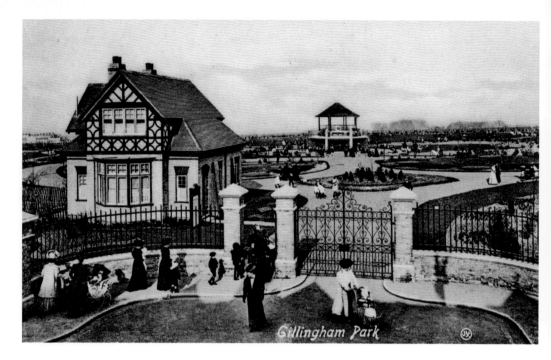

Gillingham Park

Gillingham Park was opened by the town's mayor on 25 July 1906. With Gillingham being such a built-up area, it offered a green, open space where the townspeople could relax and socialise. Today, the trees and shrubs have matured, and we no longer have such an open vista as these Victorians taking their children to the park.

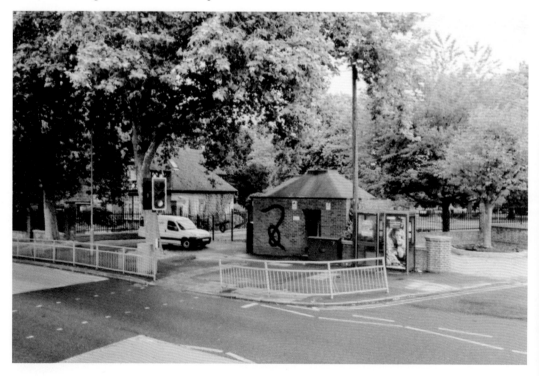

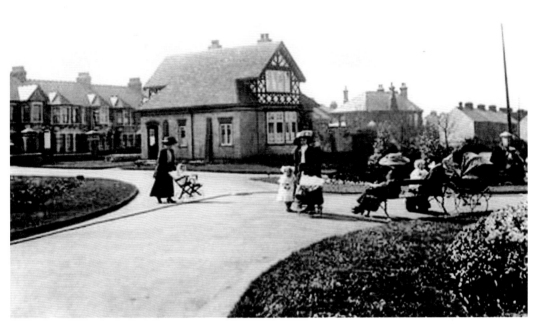

Gillingham Park
An alternative view, looking from the park into Canterbury Street in 1900.

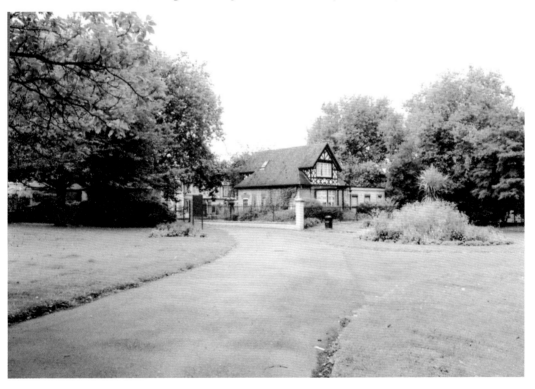

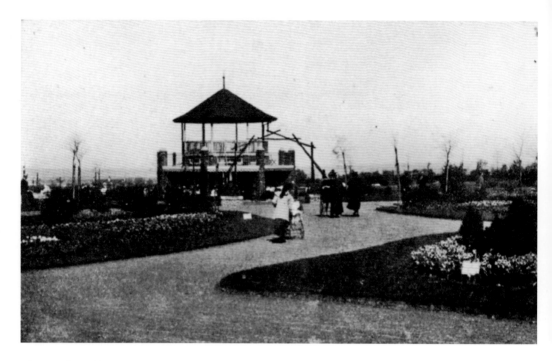

The Bandstand

In an age before portable radios and other electronic gizmos and gadgets, an almost obligatory feature of any municipal park was the bandstand, where regular brass band concerts could be heard each week. Gillingham, like the other Medway Towns, was particularly fortunate in that it not only had a wide choice of civilian bands but also had access to military bands that were stationed here.

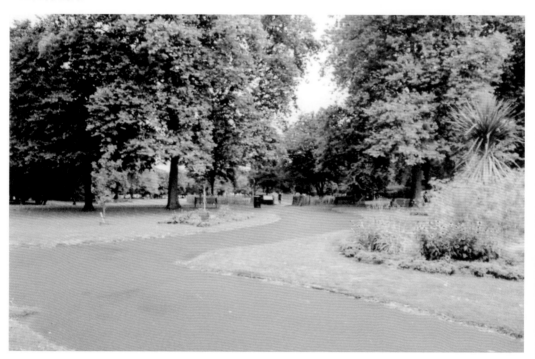

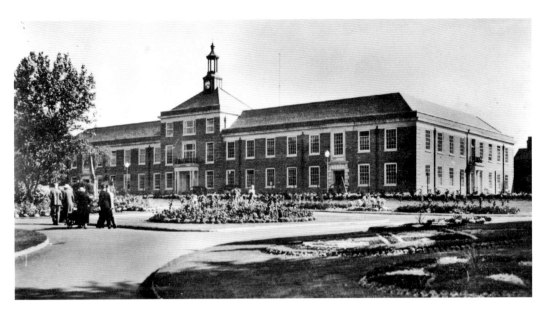

The Municipal Buildings

Overlooking the park in Canterbury Street is Gillingham's civic centre, known locally as the Municipal Buildings. It was built specifically as council offices for Gillingham Borough Council and was opened by the Lord Mayor of London, Sir George Broadbridge, on 25 September 1937. Before the Second World War began, air-raid sirens were placed on its roof, and the local Civil Defence Headquarters were housed in a single-storey building to the rear of the car park. Around 1953, Gillingham Borough Control Centre was built underground beneath part of the car park. When Gillingham Borough Council merged with Rochester-upon-Medway to form the unitary Medway Authority in 1998, the building continued to be used for council offices and meetings for several years. The new, enlarged Medway Council then moved into the former Lloyd's of London building at Chatham's Gun Wharf in Dock Road, and the Municipal Buildings became surplus to requirements. They were sold off in 2008 to become a care home for the elderly.

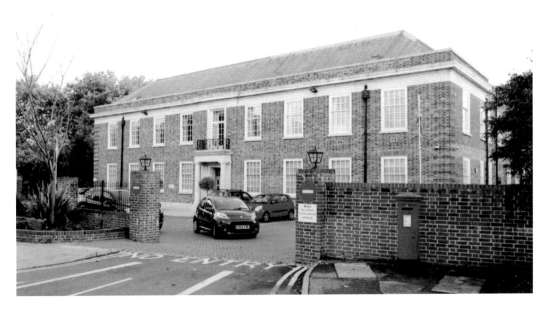

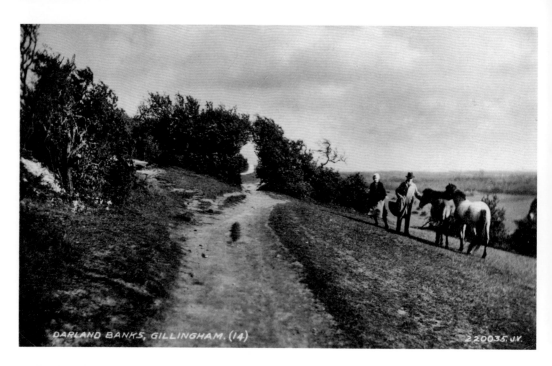

DARLAND BANKS, GILLINGHAM. (14) 220035.JV.

Darland Banks

Watling Street, the A2 road, marks the southern limit of Gillingham. Here, it is possible to access one of the area's last undeveloped pieces of countryside as it falls away, down the slope into Luton and Chatham. The Darland Banks offer a more rugged vista than that of a formal park and are therefore a perfect haven for wildlife.

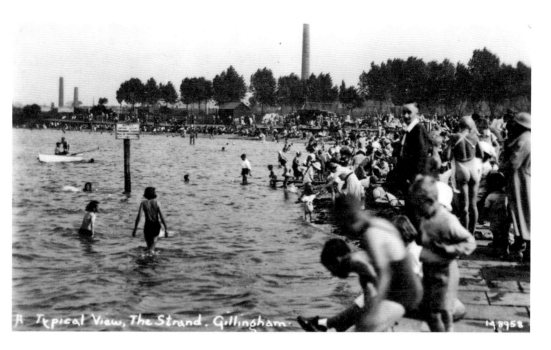

A Typical View, The Strand, Gillingham.

The Strand

The River Medway flows across the northern limits of the borough and offers an exciting opportunity for leisure activities. The Strand leisure complex, seen here, has a fascinating history. Its pool was built in 1894 by Mr Cucknow, a local baker, and was opened on 27 June 1896. It is 274 feet long and 138 feet wide. Before the pool was built it was just a hole in the mudflats, with old railway carriages where the swimmers could change. Today it is a fine, up-to-date outdoor pool. During the interwar years, a paddling pool, boating pool, putting green, bandstand and café were added, and the Gillingham Town Guide promoted the Strand as a Riverside Lido. The miniature railway was opened after the war in 1948, and the swings and roundabouts a year later.

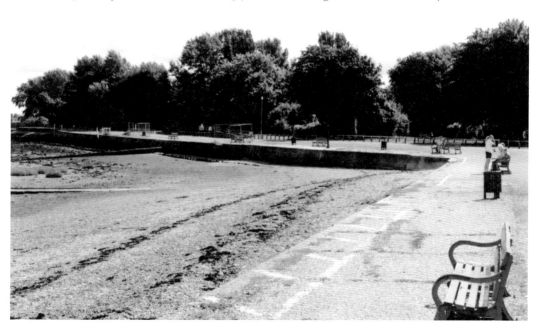

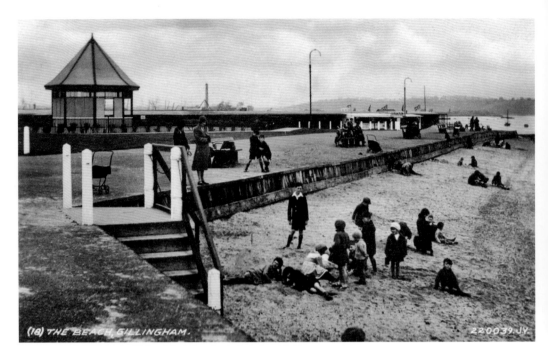

(18) THE BEACH, GILLINGHAM. 220039 JV

The Strand

Over a number of years, the Strand has grown to include many other attractions and amenities like the beach on the foreshore, which makes for a cheaper day out than 'going to the coast'. Spending a day here is a cross between a day at the seaside and a day in the park. As can be seen in this 1950s view, it is a popular spot.

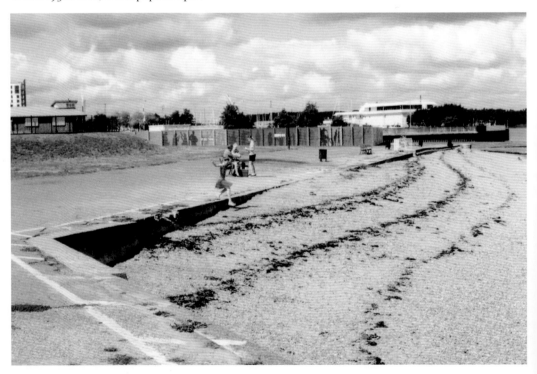

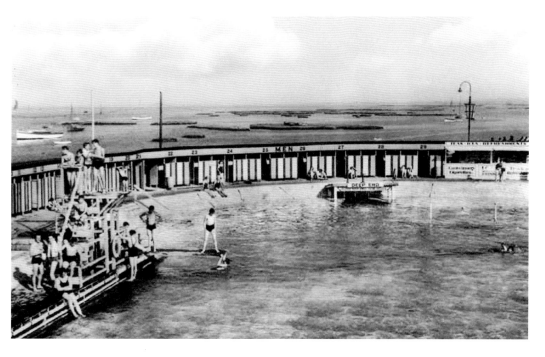

Strand Swimming Pool

The swimming pool has come a long way since its days of being just a hole in the mudflats. Here we see it in the interwar years, compared with today's magnificent pool. However, like all outdoor pools it can only be enjoyed during the summer months – and that's if we get a decent summer! When the sun does shine and the temperature rises, swimmers and sunbathers flock here in their hundreds.

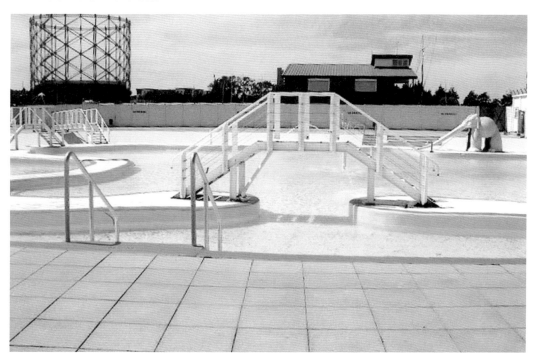

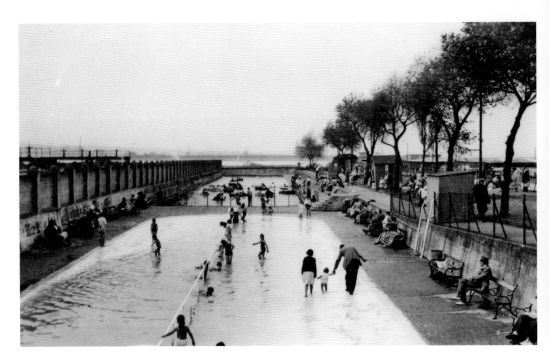

The Strand Paddling Pool

Whereas over a period of many years the swimming pool has evolved into quite a splendid, modern outdoor pool, to my way of thinking the adjoining children's paddling pool always looked like a converted dry dock for ships. Perhaps it once was – after all, beside it is the old Gillingham gasworks, which would have needed vast quantities of coal to produce gas for the town. A new children's paddling pool has since been built, but somehow I think it lacks some of the character of the old one.

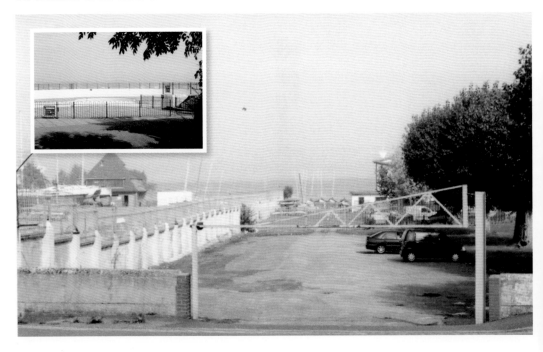

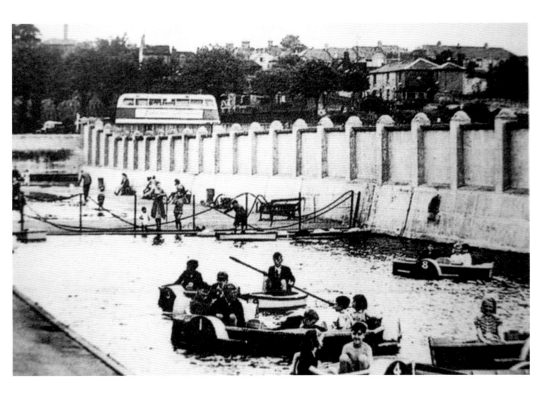

The Boating Lake

The long, narrow strip to the west of the Strand, which I have often thought of as being a dry dock, was divided into two halves. To the north, nearest to the river, was the boating lake, something enjoyed by many youngsters. To the south was the paddling pool. Today these two pools have been filled in to make a car park. Whereas the paddling pool has been relocated elsewhere on the site, the boating pool is no more, except as a fond memory for many.

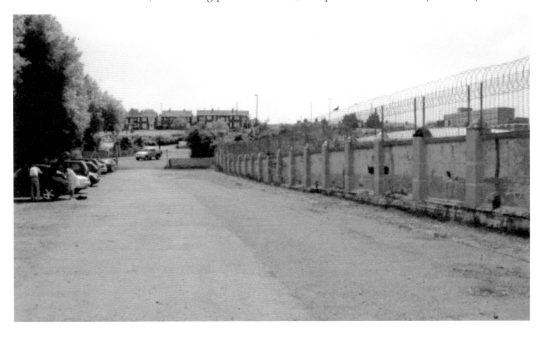

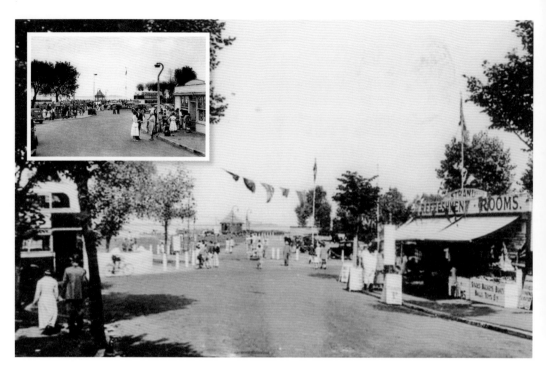

The Strand
Proof, if ever proof is needed, of the Strand's popularity in its 1940s and '50s heyday. The inset view dates to 1947.

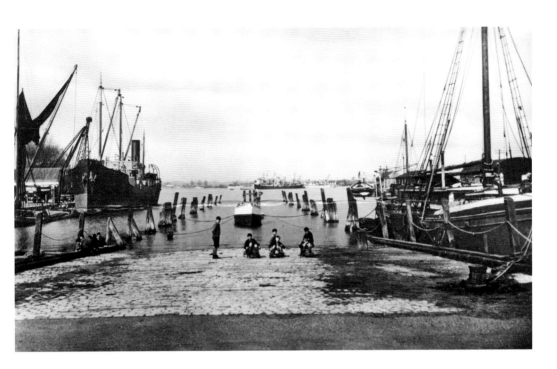

Gillingham Pier

Standing next to the entrance to the dockyard is Gillingham Pier, which must surely be on a par with the more well-known Wigan Pier for not being a pier as we understand them. It is little more than a riverside quay used by private and commercial vessels, although at one time I believe the coast-bound steamships picked up passengers from here. The slipway appears to have been a particular favourite with small boys looking for a slope on which to use their homemade soapbox racers. Only sixty years separate these two pictures, but what a difference there is.

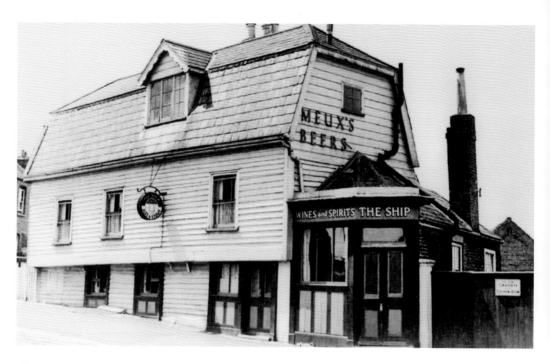

The Ship

Situated in the oldest part of Gillingham is The Ship, one of the town's oldest public houses. This timber-clad building is full of 'ye olde worlde charm'. Records show that The Ship was located in Church Street in 1711, and possibly long before that, but at some time before 1840 it was moved to its present location on Gad's Hill. The current building has a very old and rural appearance, suggesting the building might predate its use as a pub.

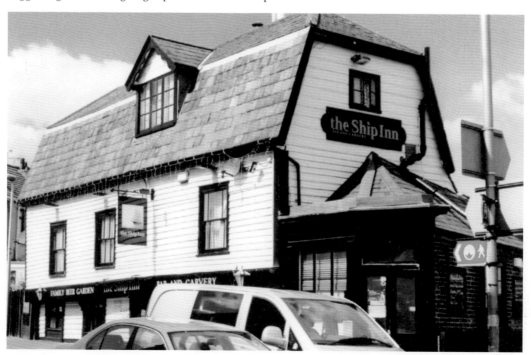

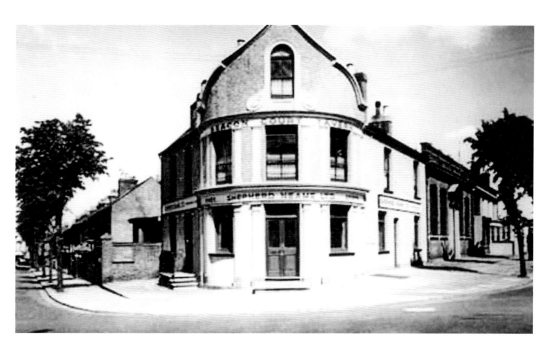

Beacon Court Tavern

Located in Canterbury Street at its junction with Copenhagen Road and Trafalgar Street, in the past few years this traditional pub has rebranded itself to become one of Medway's leading live music venues, attracting different music genres. The pub took its name from the former name of this part of Canterbury Street, Beacon Court Lane, which in turn took its name from the nearby sixteenth-century beacon built to warn of invasion. It was built in the 1860s as part of a planned housing development along Trafalgar Street, Copenhagen Road and part of Gillingham Road, a development that was trapezoidal in plan with a pair of pubs on the 'points' (the other one being the Fleur-de-Lis).

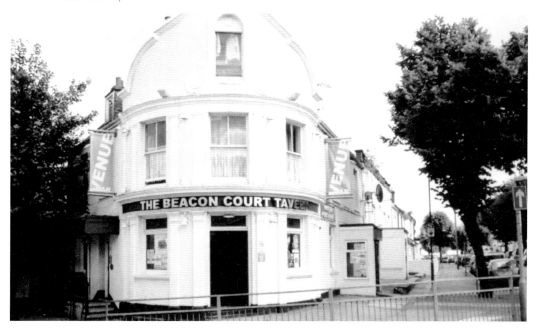

The Viscount Hardinge

The Viscount Hardinge was situated in the High Street on the corner with Marlborough Road and opened in the 1850s, but who was Viscount Hardinge? The first Viscount Hardinge served in the Peninsular War and was later War Secretary, accompanying Queen Victoria when she visited wounded Crimean veterans at Fort Pitt and Brompton in 1855. The Croneen family were the first licensees and they were still there in 1923. In 1850, it was licensed for a full seven-day week, and it was not until 1860 that it shut on Sundays. In 1863, Mr Croneen took advantage of an Act of Parliament to obtain a six-day licence, closing at 10 p.m. on weekdays, although from 1889 it stayed open until 11 p.m. on the six working days. By 1909, the Viscount Hardinge's licence was the only one in Gillingham where, if Christmas Day was a weekday, they could open for normal workday times rather than Sunday hours. For the first four decades of the twentieth century it was renamed the Lord Hardinge, before reverting to its original name. In the 2000s it was renamed the Sphinx Bar, and it closed down in early 2011. This early view, taken in 1937, shows that the building has remained structurally unaltered over the years.

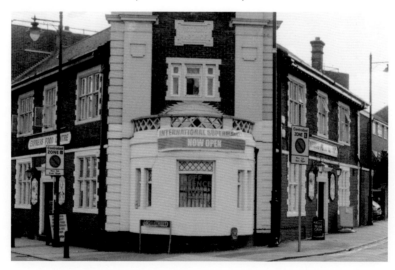

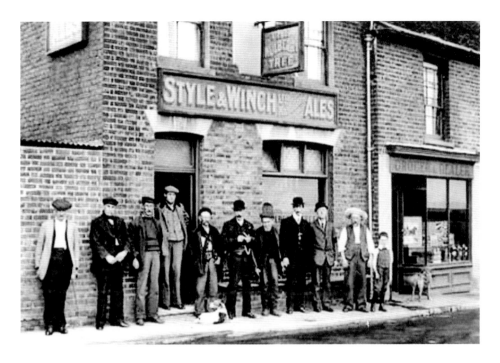

The Mulberry Tree

The Mulberry Tree was situated on the Lower Rainham Road opposite the entrance to Copperhouse Lane and, although the building still exists, it is now a private house, as is the grocery store next door. Here we see the locals eagerly awaiting opening time around 1905. The pub closed in 1973 and was the last beerhouse in the area. The Mulberry Tree beerhouse opened sometime before 1872, and got its name from a mulberry tree that grew in the garden. It was probably built to serve the men building forts in the area. Before the sea wall was built on the nearby riverbank, the pub often flooded at spring tides.

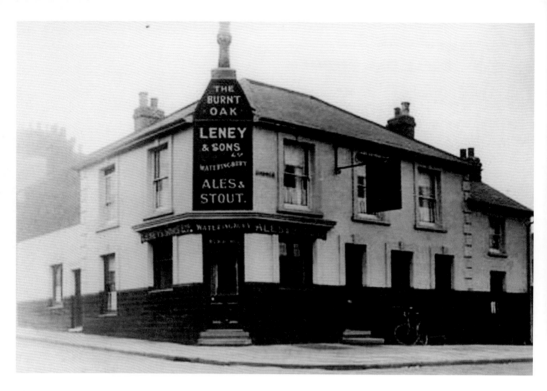

The Burnt Oak
The Burnt Oak was situated in Gardner Street on the corner of Burnt Oak Terrace, as seen here in 1910. It closed down long ago to become flats, having been a pub since about 1870.

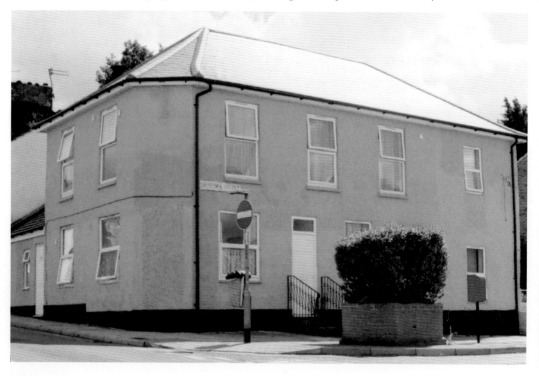

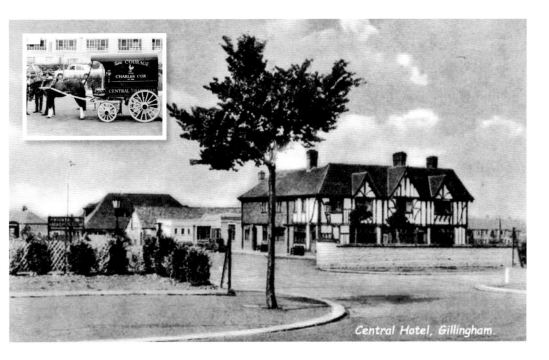

Central Hotel, Gillingham.

The Central Hotel

The Central was built in the 1930s and initially its main appeal lay in the large tea rooms and kiosks, which were a favourite stopping-off point for coaches travelling from London to the coast before the M2 motorway was built. Watling Street, the A2, was then the main road through Kent. For many years, the hotel was owned by local businessman Charlie Cox and his family. In the 1980s, it became a popular local nightclub, The Avenue, and had a change of name to Bar Rio before being demolished in 2003. Today, with all traces of the Central having gone, the site has now been absorbed into the surrounding housing estate.

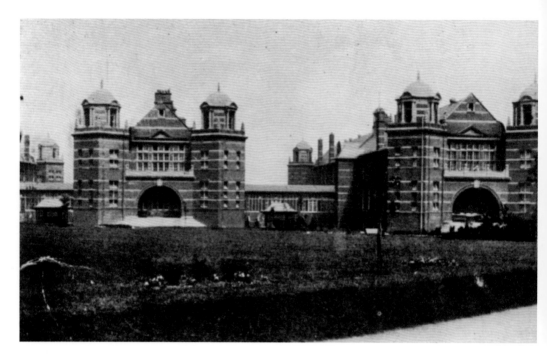

The Royal Naval Hospital

A Royal Naval Hospital was run by the Royal Navy specifically for its own personnel. Today, no Royal Naval Hospitals as such survive, except for one, which has become a tri-service military hospital. Most former establishments have become civilian hospitals, like this one in Gillingham, now known as the Medway Maritime Hospital. This early view of the hospital was taken in 1913, just eight years after it opened.

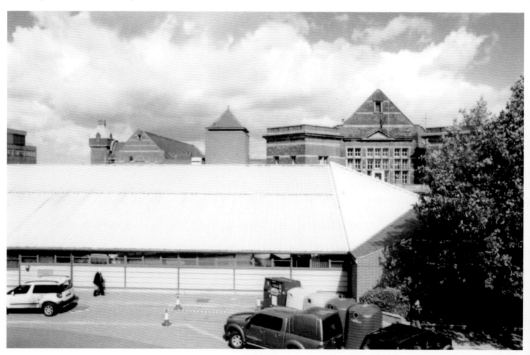

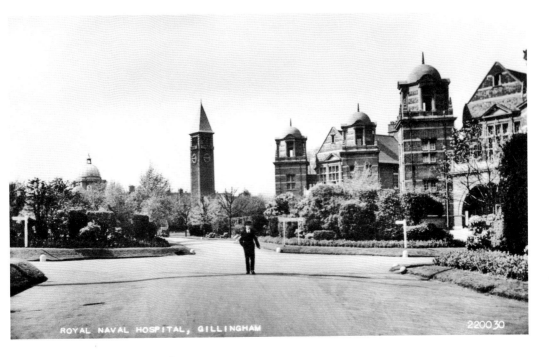

ROYAL NAVAL HOSPITAL, GILLINGHAM 220030

The Royal Naval Hospital

The hospital was opened as the Royal Naval Hospital by King Edward VII on 26 July 1905 as a replacement for the 252-bed Melville Hospital (Naval), which was not large enough to deal with the increasing numbers of Navy personnel moving into Chatham. The Melville Hospital had been built in 1828 and was clearly in need of modernisation. After closure it became part of the Royal Marines' barracks. This 1959 view was taken shortly before the hospital was transferred to the NHS.

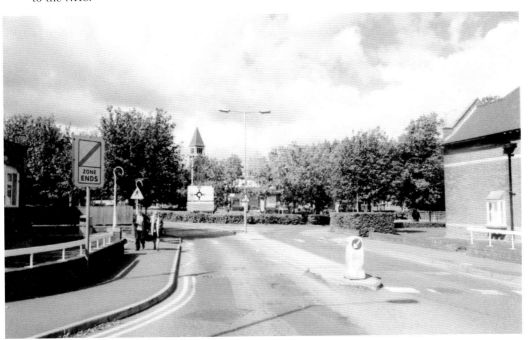

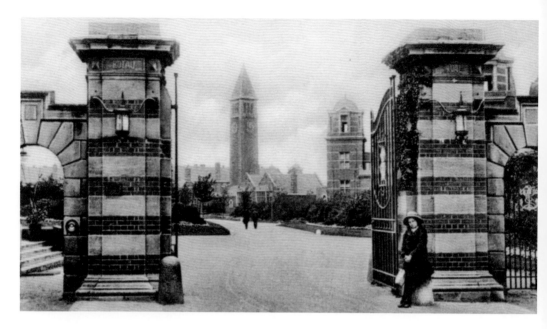

The Royal Naval Hospital

On 15 January 1961, the hospital was transferred by the Admiralty to the NHS and it became part of the Medway Health Authority. The hospital closed for modernisation and, after some delays, reopened in 1965 under the name Medway Hospital. After a £60-million development in 1999, the hospital changed its name to the Medway Maritime Hospital in honour of its past Naval connections and services were transferred from the neighbouring hospitals, St Bartholomew's in Rochester and All Saints' in Chatham. One noticeable change is the way in which Windmill Road once ran past the entrance en route to Chatham Hill, the main road. Now it is curtailed at the hospital's entrance to allow Montgomery Road unimpeded access straight into the hospital for ambulances and other traffic. Somewhere within all this modern architecture there are still visible traces of the original building.

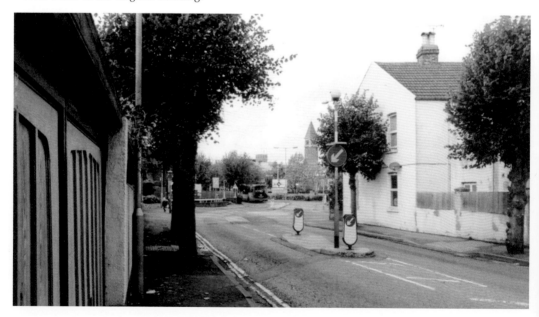

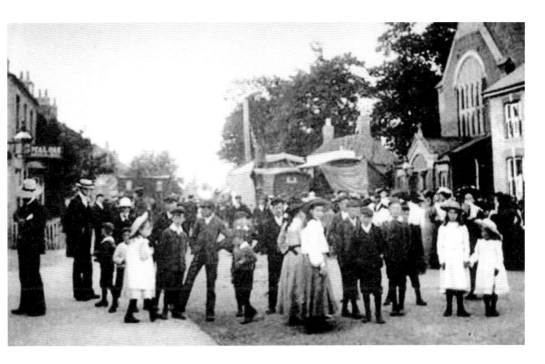

The Salvation Army Church, Green Street
Taken around 1905, this is the Salvation Army citadel in Green Street, opposite the post office. The streetscape has changed dramatically in the intervening hundred-or-so years, but the front of the church looks about right for the building that is there today.

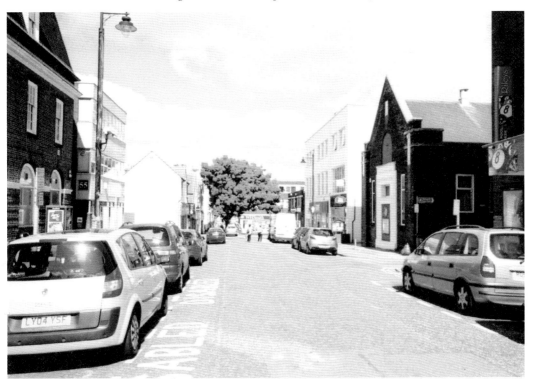

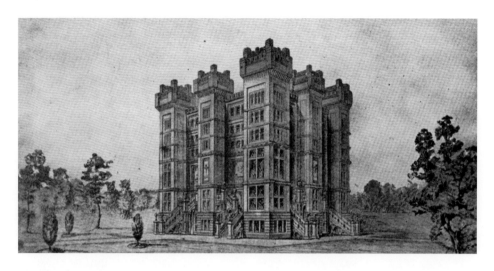

A Strange Religion

A distinctive feature on Gillingham's landscape for many years was the ruined remains of Jezreel's Temple, which stood at the top of Canterbury Street on the town's boundary with Chatham, but exactly what was it? It was intended to be a sanctuary, an assembly hall and the headquarters of the New and Latter House of Israel, a sect known as the Jezreelites. It took its name from its leader, James White, who changed his name to James Jershom Jezreel upon joining the sect. Architecturally, the building was intended to be a perfect cube, each side being 144 feet long, but the architects pointed out that this design was impractical and agreement on a modified version of 124 feet on each side and 120 feet high at each corner was reached. It was to be built of steel and concrete with yellow brick walls and eight castellated towers. The trumpet and flying roll, crossed swords of the spirit and the Prince of Wales feathers (signifying the Trinity) were to be engraved on the outer walls. The circular assembly room was a vast amphitheatre, said to be capable of accommodating up to 5,000 people, and in the roof would be a glass dome, 94 feet in diameter. The estimated cost for these plans was £25,000 and completion was set for 1 January 1885. Sadly, the grand plan never materialised and, by 1918, the derelict building stood empty and forlorn. Here we see the architect's original drawing of the completed building, compared with a view of how far this work progressed.

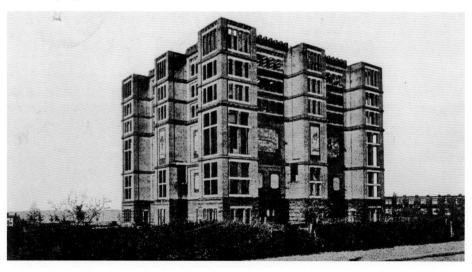

The Surrounding Area

Outside, it was planned to have gardens and stately avenues from adjoining streets, making it a focal point for the area. Around the perimeter of the site there were shops and accommodation for Israel's International College. Many of the Jezreelites were tradespeople and all who joined the sect were required to give their property and money to the cause, but still make a living somehow. The shops around the new headquarters were for that purpose and included a German bakery, a tea merchant's, a greengrocer's, a carpenter's, a dairy, a jeweller's, a cobbler's, a printing firm and a smithy. Even though the shops have now gone, traces of the brickwork remain in the walls of an alleyway.

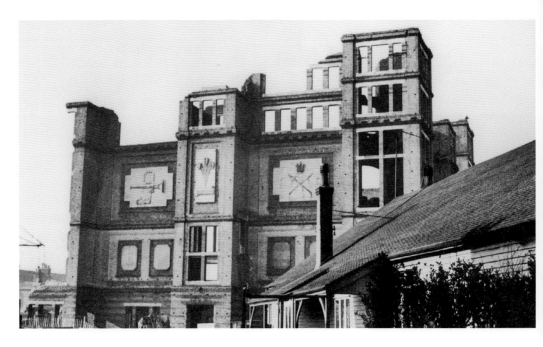

Jezreel's Tower

After Jezreel's death on 2 March 1885, the sect was taken over by his wife, Clarissa, who ensured the building work continued and the foundation stone was laid on 19 September 1885. Mrs Jezreel died suddenly from peritonitis in July 1888, aged twenty-eight. The sect fragmented and work on the tower was suspended. The tower and peripheral buildings were put up for sale in 1897 but the bidding failed to reach the asking price and it was six years before a buyer was found. By 1905, the Jezreelites had rent arrears and the tower's owners repossessed the building and began its demolition. But then the contractors themselves were declared bankrupt and the tower remained a derelict shell until its complete demolition in 1961. The remaining buildings associated with Jezreel's Tower at the top of Canterbury Street were demolished in late 2008.

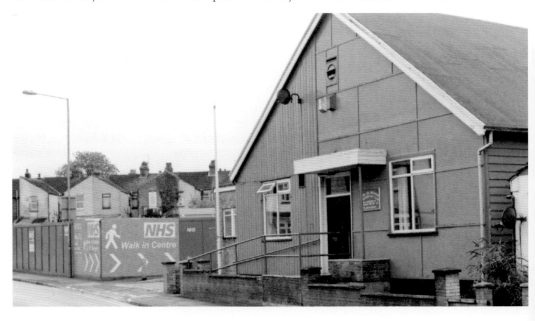

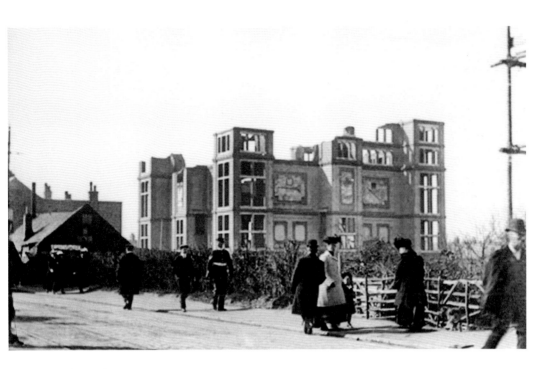

Canterbury Street

This is believed to be an early view of Canterbury Street, close to its junction with Watling Street. This is evidenced by the omnipresent Jezreel's Tower and the single-storey building that later became the Conservative Club, seen on the left. This view must date to the late nineteenth century. It predates the town's housing boom as there are no houses to be seen here, unlike today. To the right of the picture, however, scaffolding can clearly be seen, so perhaps the new houses had just reached here.

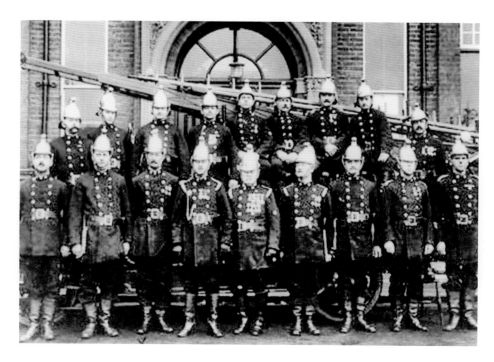

The Fire Brigade

Gillingham's Fire Brigade, *c.* 1929, taken outside the former Adult Education Centre in Green Street, which stood next door to the fire station. Earlier this year both buildings were sold at auction. Today, Medway's fire and rescue services are based in one central fire station in Watling Street.

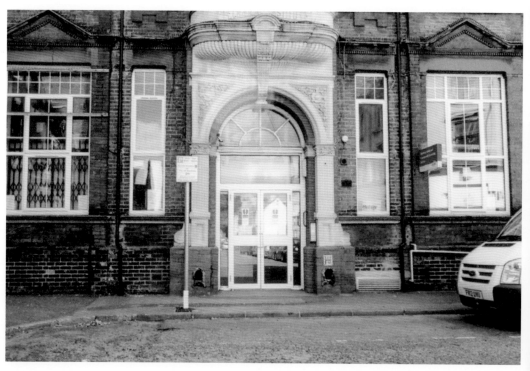

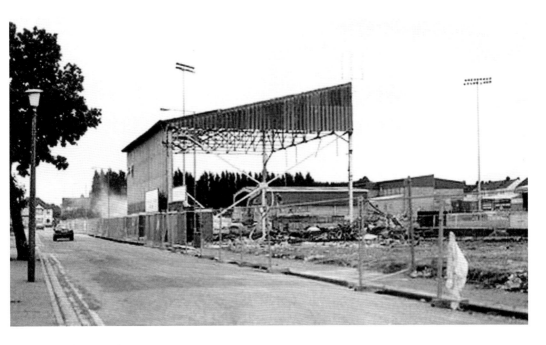

Priestfield Stadium

Gillingham is the only town in Kent to have a football team playing League football. The club was formed by a group of businessmen on 18 May 1893, with a view to creating a football club that could compete in larger competitions. To do this, they required an enclosed playing field where an admission fee could be charged. They formed New Brompton FC and purchased a plot of land, later named Priestfield Stadium, where they laid out a pitch and constructed a pavilion. New Brompton's first team played their inaugural match on 2 September 1893. Soon after, they became Gillingham FC, the 'Gills'. Since 1997, the ground has undergone a redevelopment programme, transforming it into the stadium we have today.

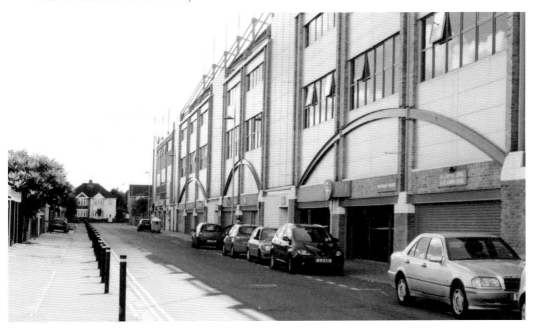

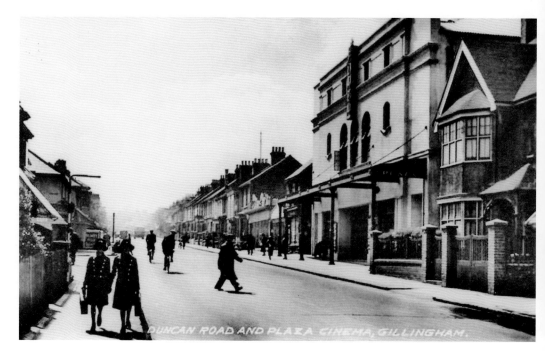

DUNCAN ROAD AND PLAZA CINEMA, GILLINGHAM.

Duncan Road

Duncan Road is a main thoroughfare linking the High Street to Watling Street. Dominating the streetscape was the Plaza cinema, a building that has been demolished and replaced by a supermarket. It closed as a cinema in November 1980 and was transformed into a television studio for TVS, the predecessor of Meridian. This was only until their Maidstone studio was ready for use in 1987, when the building was sold to become a laser gaming venue. By 2000, that had come to an end and Aldi bought the site, totally demolished it (despite it being listed), and built a supermarket there.

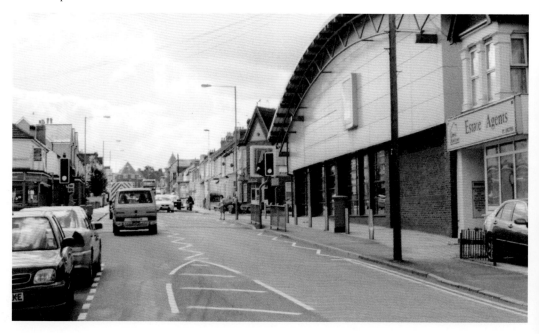

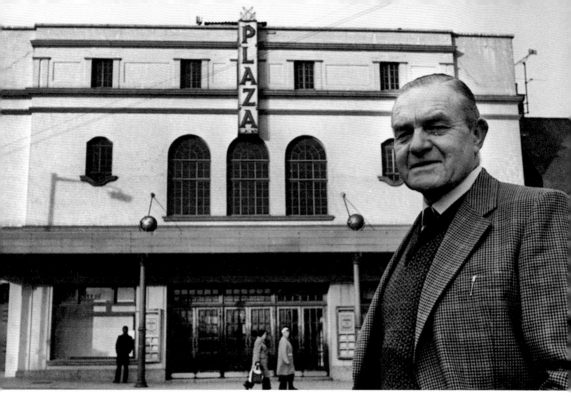

The Plaza Cinema

The Plaza cinema opened on 12 October 1931 in the heyday of the British cinema industry and was the first of Medway's new breed of 'super-cinemas'. It had seating for 1,800 people and its first film was Maurice Chevalier in Monte Carlo. The cinema was designed in a Neo-Classical style by architect E. J. Hammond and it was owned by brothers Horace and Walter Croneen. Here we see Jack Croneen outside the Plaza after it closed in 1980. He headed the company, Plaza Super Cinema (Gillingham) Ltd, and managed the cinema from 1946 until its closure. A fascinating architectural feature of this cinema, for me at least, was the four columns that supported the entrance canopy. They had originally been the supports for the overhead cables from Gillingham's tramway system, which ceased operation in 1930.

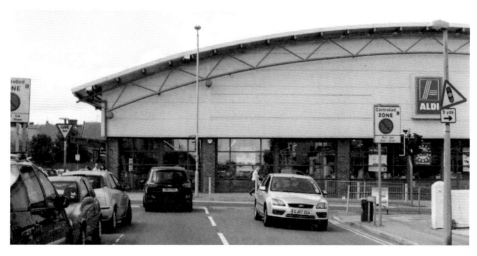

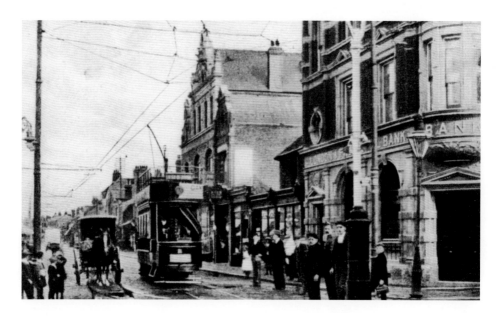

The Tramway

In June 1902, a transport revolution arrived in the Medway Towns in the guise of a tramway system, set up by the Chatham & District Light Railway Company. In earlier times, those who wanted to go from Gillingham to Chatham, Rochester, Luton or Strood had to either walk or hail a horse-drawn cab. To begin with, the service ran only between Gillingham and Chatham, a boon for the dockyard workers, but in 1906 it was extended to Rainham and through Rochester to Borstal and Strood by 1908, when the system reached its fullest extent. In 1927, Maidstone & District Motor Services Ltd became the company's major shareholder and the company changed from trams to buses on 1 October 1930. Late in 1954, Maidstone & District Motor Services (M&D) introduced proposals to merge Chatham Traction into their organisation and their green and cream liveried vehicles became a part of the streetscape.

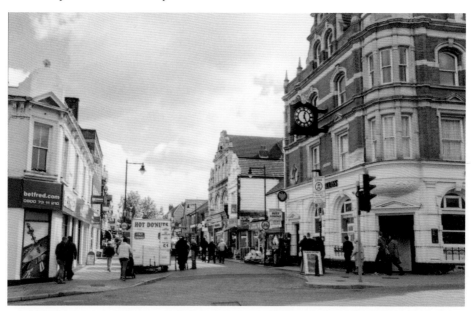

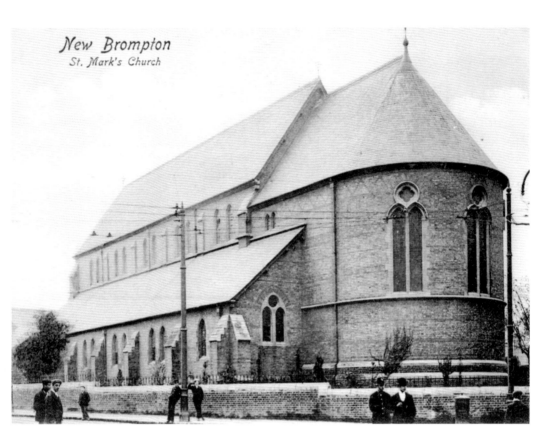

New Brompton
St. Mark's Church

St Mark's Church
Built between 1864 and 1866, this church has changed little over the years. Designed by J. P. St Aubyn at a cost of £5,800, this brick-built church was constructed on the site of an earlier wooden building for the expanding population in this part of town.

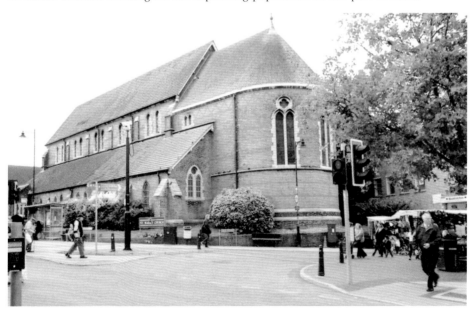

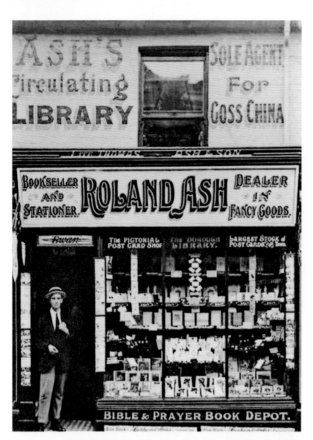

No. 90 High Street
A name synonymous with postcard production in the early 1900s was George Ash, whose family had a shop in Sittingbourne. Roland Ash was a younger son who opened this shop in New Brompton High Street soon after the death of his father, when George Jnr took charge of the Sittingbourne shop.

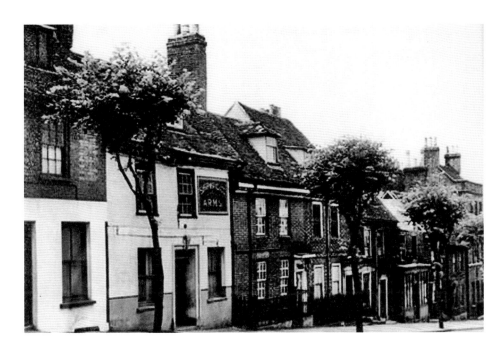

The Shipwrights Arms

It is almost impossible to look at the history of Brompton without mentioning its pubs; in fact, the first building in Brompton became a pub less than five years after it was built. As early as 1754, there were a dozen pubs in the six streets that made up Brompton, but their number became so great that from the 1890s to the 1930s the local authorities deliberately closed many down and transferred their licences to newly built pubs elsewhere in the Medway Towns. The gradual reduction of the military in the area, along with the closure of the dockyard and modern economic conditions, mean that today only four pubs remain. Situated in the older part of Brompton is the Shipwrights Arms, which was already established by 1754 but closed in 1951 when its licence was transferred to the new Flying Saucer in Hempstead. Here we see the pub as it was in 1920.

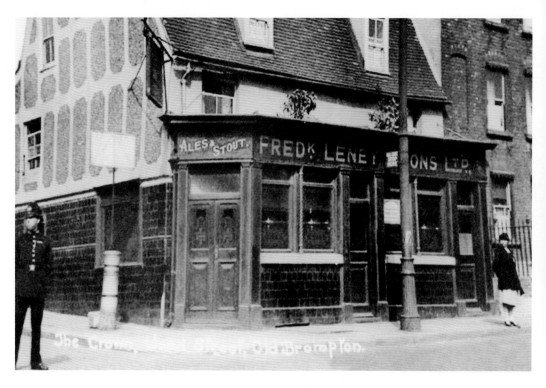

The Crown

Another of Brompton's long-gone pubs is The Crown, which once stood in Wood Street. This one was particularly difficult to locate, as Wood Street was totally demolished in the 1950s, but I believe this is where it once stood. In its heyday, Wood Street had at least ten pubs and ale houses, despite it being somewhat short in length – but it was, after all, a main thoroughfare.

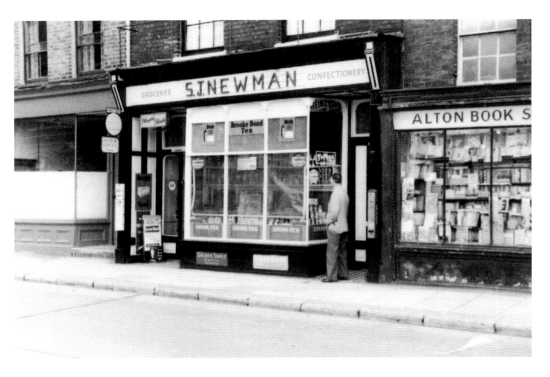

Nos 49–53 Brompton High Street

A couple of random shops that once formed part of Brompton High Street. Now long gone, it is known that Sidney J. Newman's grocery shop was at No. 51 High Street in 1955 and 1961, and Walter R. Powell, trading as Alton Book Shop, was at No. 49 on both dates. The empty shop on the left, No. 53, is unrecorded in 1955, but in 1961 it was a café owned by Mrs S. E. Newman.

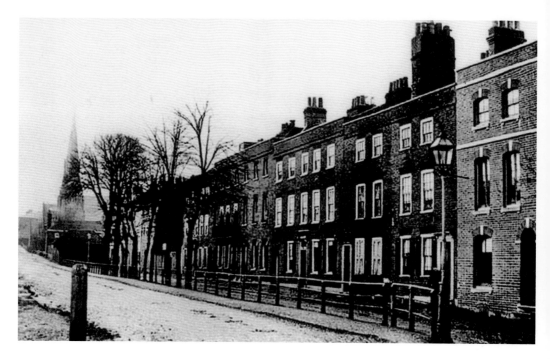

Mansion Row, Brompton

Formerly known as Mansion Road, Mansion Row was built to house military officers in the mid-eighteenth century and stands close to the entrance to the barracks. This view was taken c. 1850. In the middle distance is Holy Trinity church, which was built in 1848 and demolished in 1961.

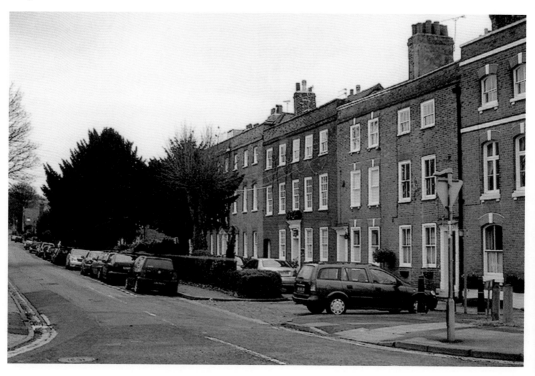

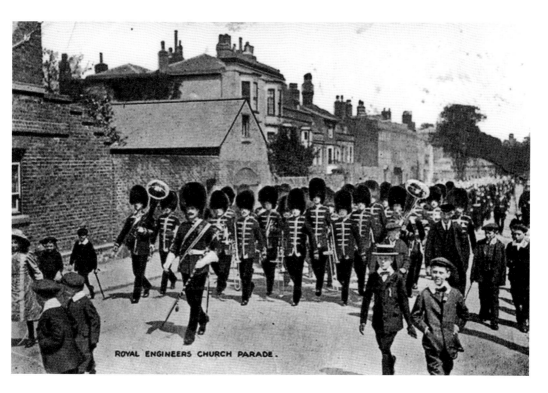

ROYAL ENGINEERS CHURCH PARADE.

Time for Church Parade

A familiar sight in any garrison town in days gone by was the troops marching to church on what was known as a church parade. Here we see the band of the Royal Engineers at the turn of the nineteenth century leading the corps along Mansion Row to the garrison church. Their heavily braided jackets and bearskins are very different to the uniform worn by the band these days.

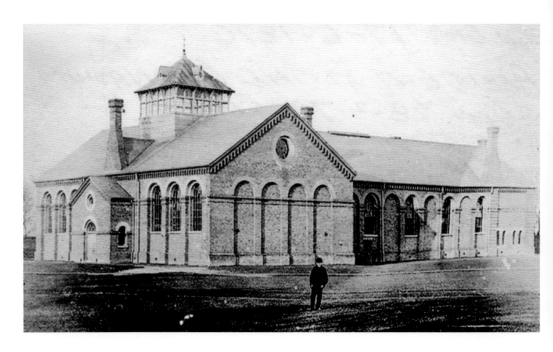

The Garrison Gym

Built by government contractors Matthews & Sons of Dover in 1863, the gym opened in 1864. Designed as somewhere to instruct the officers and sappers in physical education and training, the main specification stated that the main building should be 200 feet in length, and was to include a school of arms 100 feet long by 50 feet wide, together with a separate gymnasium with a prepared soft floor of exactly the same dimensions. Communicating with the two large rooms would be an officers' fencing room, measuring 50 feet by 25 feet, together with dressing facilities and other rooms for officers and men, as well as instructors and other apartments. The whole would be surmounted by a handsome square tower, rising to the height of 70 feet. Today, the building is very much unchanged and continues to be used for its original purpose.

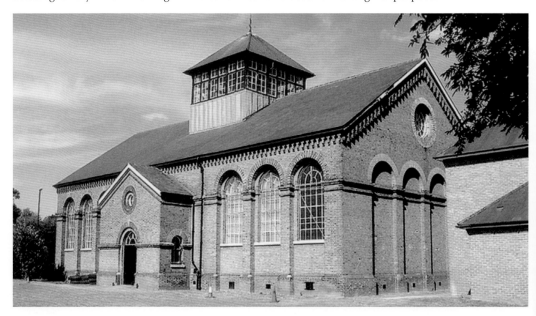

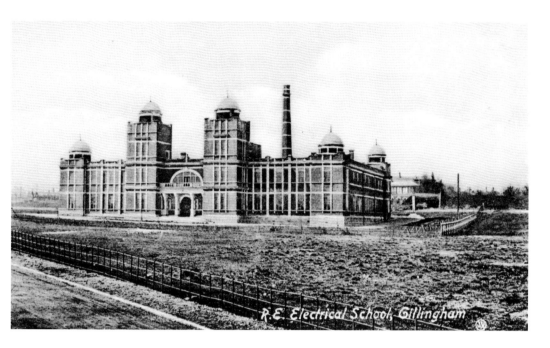

R.E. Electrical School, Gillingham

The Royal Engineers Electrical School

Separating Brompton from Gillingham is the Royal Engineers barracks, an important part of which for many years was the Ravelin Building in Prince Arthur Road, the headquarters of the Royal School of Mechanical Engineering. Built in 1872/73, it was one of three schools sappers could attend after basic training. Today, the building houses the Royal Engineers Museum. The School of Military Engineering and the museum were both founded in 1812, and the library was founded in 1813. The museum moved to its current site in the Ravelin Building in 1987, where its collection received 'designated' status in 1998. It is recognised as having an outstanding collection of national and international significance, and is one of only three military or regimental museums in the country to hold this status.

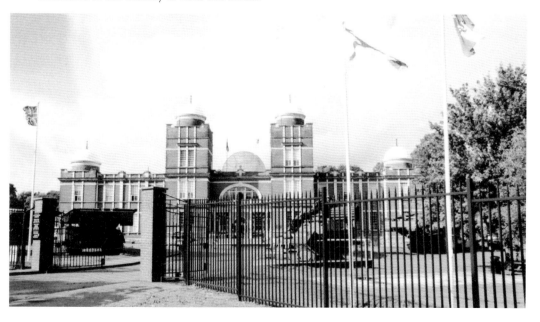

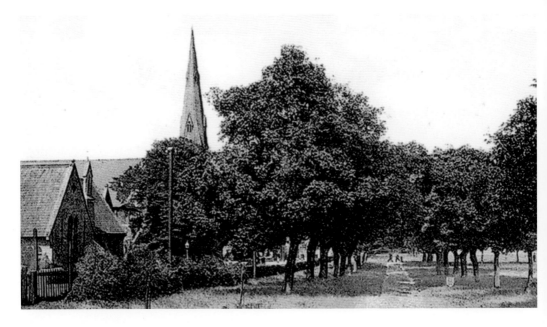

Holy Trinity Church

A view of Holy Trinity church looking north-east, featuring a path leading through an avenue of trees. The buildings to the left of the picture are the Conway Hall and Trinity Church School buildings. In December 1868, the War Secretary gave permission for a portion of the inner line of fortifications adjoining Fort Amherst, Chatham, to be set apart as a recreation ground for the use of the officers posted to the garrison. The avenue of trees was part of this Victorian park, which included carriage drives and tennis courts. The open land behind King's Bastion is now much more overgrown than it was, although the route of the tree-lined avenue can still be seen. Many of the trees have been felled but allowed to regrow. Holy Trinity church itself has long gone but some of the school buildings can still be seen and are incorporated into the modern housing development.

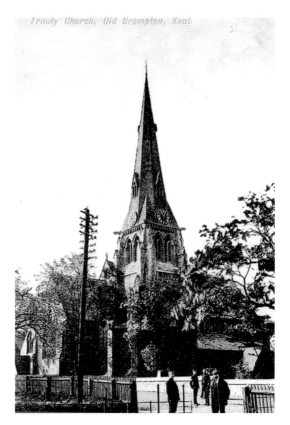

Holy Trinity Church

Holy Trinity was the parish church of Brompton in the late nineteenth and early twentieth century. Built in 1848 together with a school, it remained in use until the 1950s when, as a part of Brompton's redevelopment, it was moved to Twydall. Originally there were plans to move the church stone by stone, but only some of the internal fittings and fixtures were moved and the main structure was demolished. The school remained in situ for another quarter of a century and has now been converted into housing.

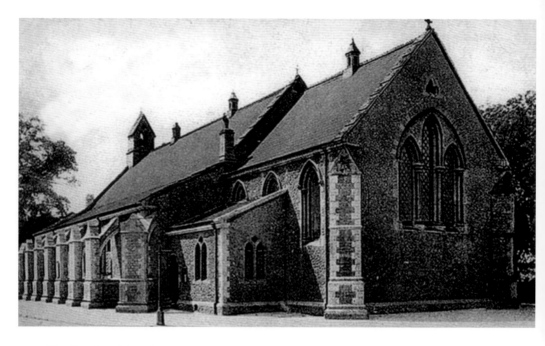

The Garrison Church

The garrison church is little changed from how it appeared a hundred years ago. The main alterations are the addition of a new door and remodelling of the porch, and the removal of the air vents from the roof. The garrison church dates from 1854 and cost £4,500 to build. In 1851, it became evident that the existing chapel was not adequately meeting the needs of the large garrison, which used it as a chapel and a school, together with the needs of the Royal Engineers for model rooms and other instructional rooms. It was also expected that the Sappers and Miners Training Depot would be moved from Woolwich to Chatham. On 17 October 1851, the War Office suggested that the chapel in Brompton Barracks should be used as a model room and that a new chapel was to be built as close as possible to the infantry barracks (now Kitchener Barracks).

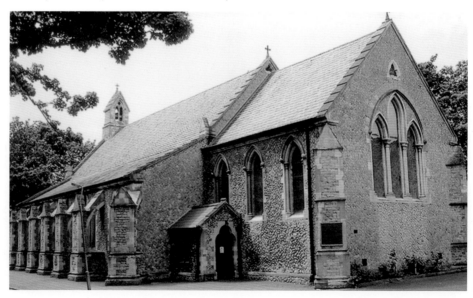

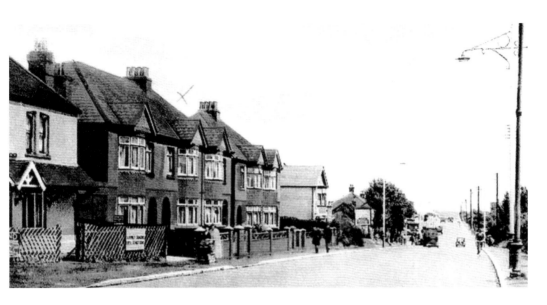

Rainham Mark

Linking Gillingham to Rainham is Rainham Mark, a small hamlet formerly consisting of houses, a few shops, a post office, a petrol station and a pub. Its name is said to be derived from the division between the areas of the Men of Kent and the Kentish Men. Although the River Medway between Chatham and Maidstone has long been regarded as the dividing line between the two, legend suggests the true position of the line might be further to the east at Rainham Mark. In support of this, it is said an ancient boundary stone once stood here near the Hop and Vine pub, long since replaced by a milestone. An alternative theory suggests the name was originally Rainham March (like the Welsh Marches) and delineated the border between the Royal Lathe of Milton and the Lathe of Aylesford, two land divisions dating back to Anglo-Saxon times. There is no written evidence to support either theory, of course, but all myths and legends do have some basis in fact. This 1920s or '30s view looks eastwards towards Rainham. When first built, these houses overlooked open meadowland, but today they overlook a supermarket and, before that, Bowater's packaging plant.

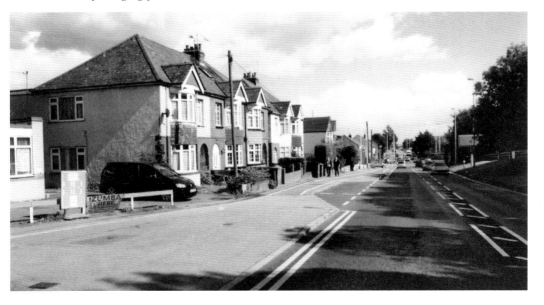

Rainham Mark's Pub

Most communities have a pub at their heart and, despite its compactness, Rainham Mark is no exception. Originally called the Belisha Beacon, it changed its name to the Hop & Vine and has since closed for business. Its licence was transferred from the Crown in Wood Street, Brompton, on 23 May 1938, although the name change was not confirmed until 15 August 1938. The building design seems consistent with this period.

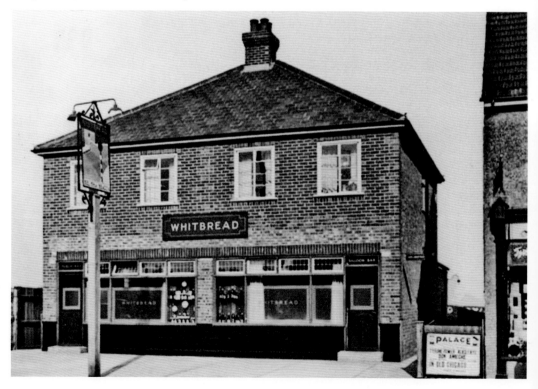

Rainham Mark Petrol Station

For many years there was a modern self-service petrol station at Rainham Mark, now closed down and looking derelict. Here we see how petrol was dispensed in earlier times, from a pump manned by an attendant. In the background can be seen the Belisha Beacon pub. Judging by the dress of the two ladies, this picture was possibly taken in the 1950s or 1960s.

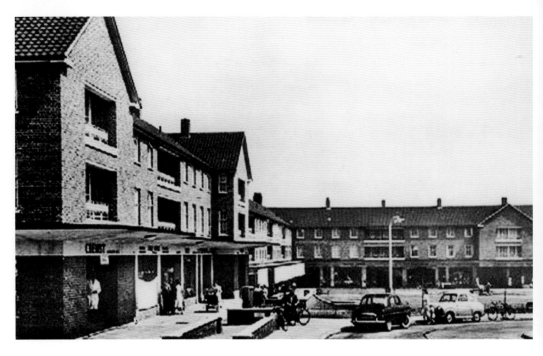

Twydall Estate
Gillingham's post-war housing estate built at Twydall, sandwiched between the A2 road and the River Medway. Its shopping centre has changed little since this view was captured in 1961.

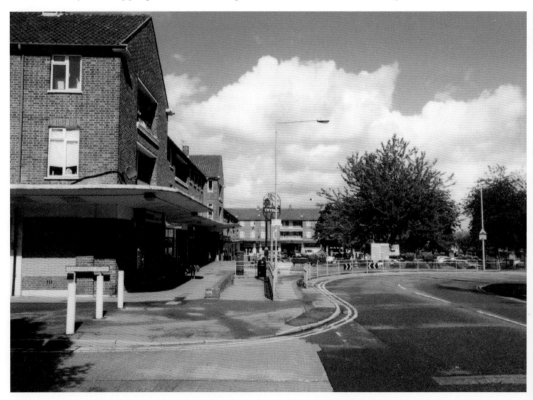

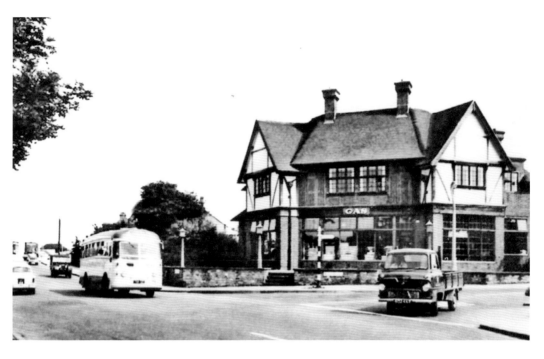

The Manor Farm

Formerly a showroom for the South Eastern Gas Board, this Tudoresque building later became a popular Beefeater restaurant called the Manor Farm. In recent years, a Premier Inn has been built in its spacious car park.

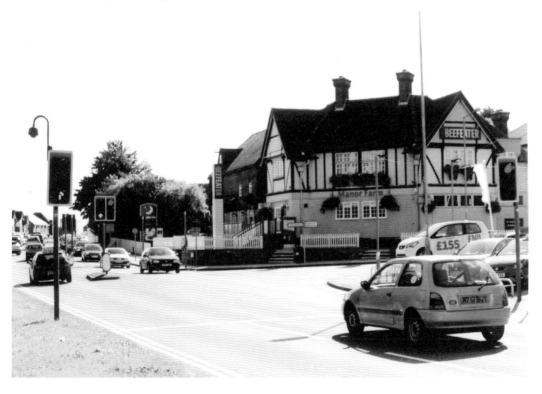

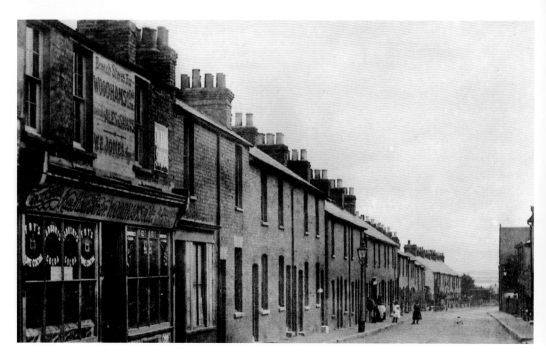

Ivy Street, Rainham

One of the many roads of small terraced houses that run back from the High Street towards the river, which could clearly be seen in earlier times. Today, the trees have matured and now block this view. These houses were all built in the late nineteenth and early twentieth century. This view was taken *c.* 1912.

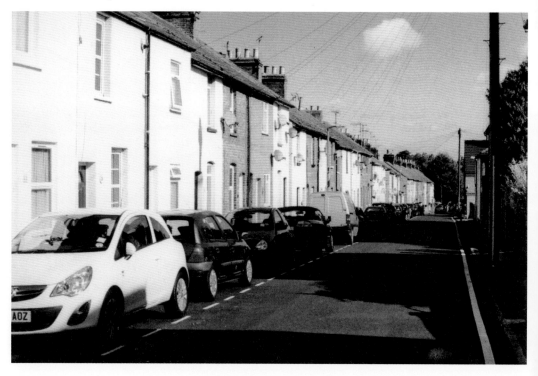

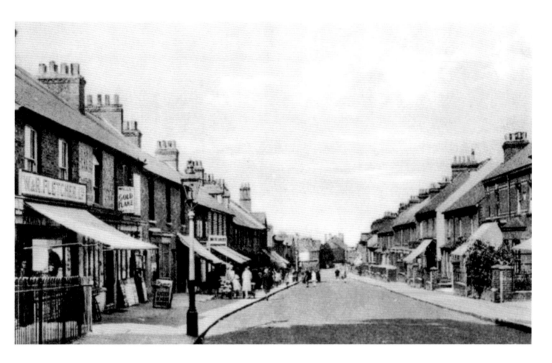

Station Road

By 1927, when this picture was taken, even though Rainham was still a relatively small town, it had none of the large national chain stores that were starting to creep into other parts of the Medway Towns. To the left of our picture is the butcher's, W. & R. Fletcher Ltd, beside which is the newsagent's, Fred Kitney. The railings surrounded the playground of the local school. Somewhere in this streetscape is the entrance to the Rainham shopping centre and Wilkinson's, while where the school once stood is a bank.

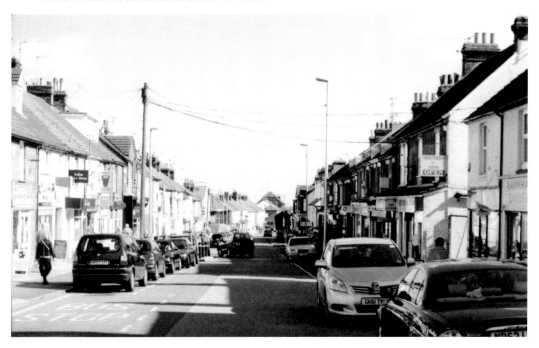

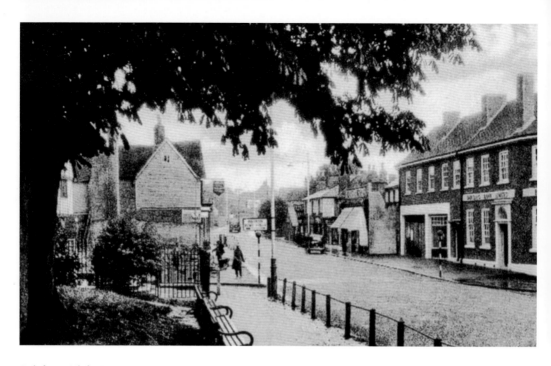

Rainham High Street
As late as the 1950s there was little traffic on the main roads. Taken from outside the church, this view looks westwards.

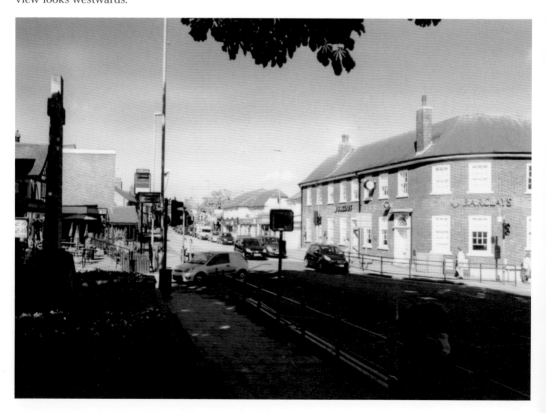

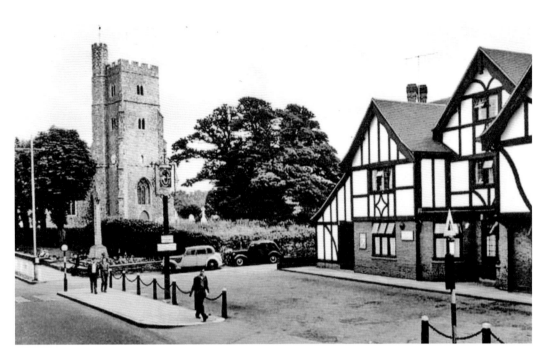

A Church and a Pub

Two of Rainham's most distinctive features are its church and the adjoining pub, the Cricketers. Even though the original settlement of Rainham dates back to AD 811, the earliest church dates to 1137 and is dedicated to St Margaret. The tower is a major local landmark and was built in around 1480. It stands 30 metres (100 feet) high with an octagonal stair turret, probably housing a beacon at the top to act as one of a chain between the coast and the capital. The tower houses a peal of eight bells.

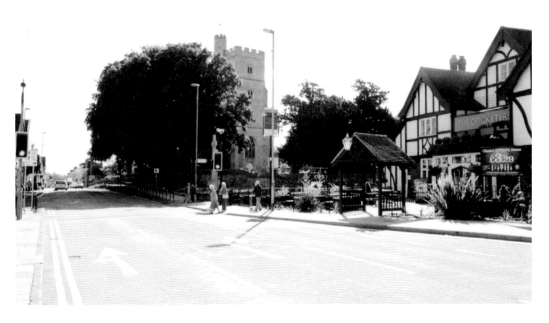

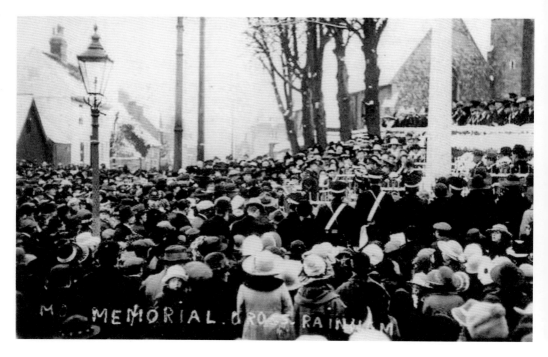

The War Memorial

Rainham's war memorial stands close by the church and lists the names of the ninety-nine local men who died between 1914 and 1920. It was unveiled on 12 December 1920 by Maj.-Gen. H. F. Thuiller, having been built by Messrs Millen & Chrisfield.

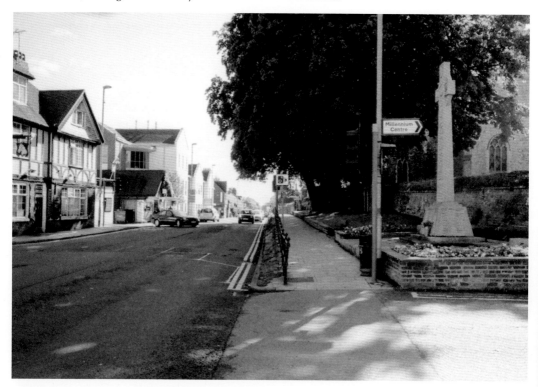

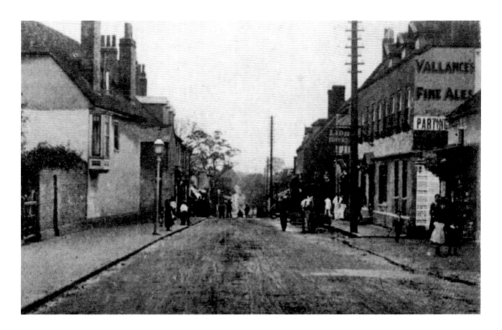

Rainham High Street

This is the eastern end of the High Street, taken in the early 1900s when cars were a rarity. To the right can be seen one of Rainham's oldest pubs, the Green Lion, which at this time was known as the Lion. Standing on the main A2 road, it was in fact a coaching inn. Its outward appearance has changed very little, if at all, in the past 100 years. A landlord from the 1960s was curious about the exact age of the building and, after inspecting the roof timbers, the experts told him it dated to at least the fourteenth century. Subsequent investigations have revealed a tunnel from the pub's cellar to the neighbouring church and a priest hole in the roof space.

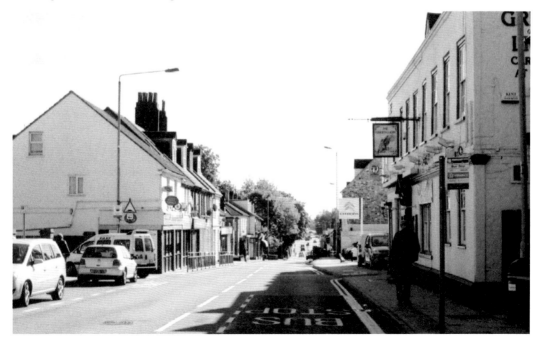

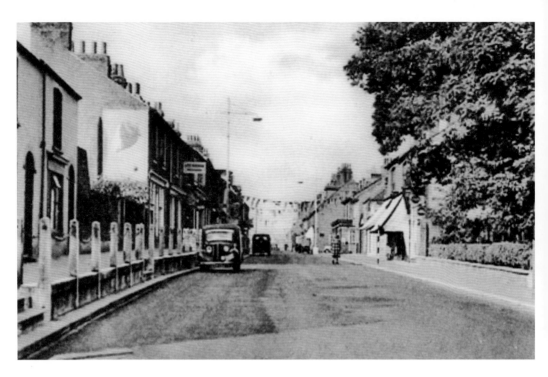

Rainham High Street
Looking westwards into the High Street. Taken around the 1950s, it seems that Rainham had something to celebrate, judging by the bunting – possibly the Coronation?

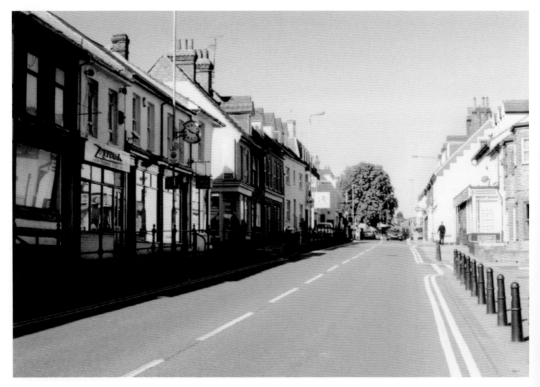

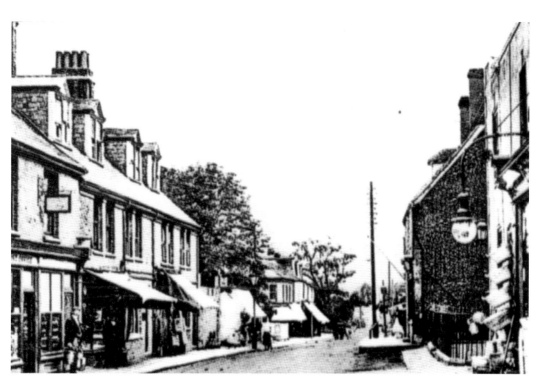

Rainham High Street

The High Street, looking eastwards from the Green Lion. With few clues to suggest a date, I would hazard a guess at the late 1800s.

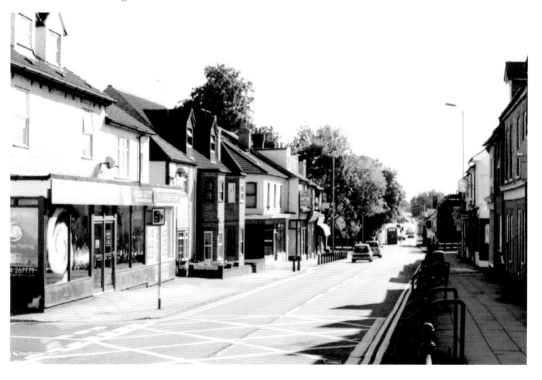

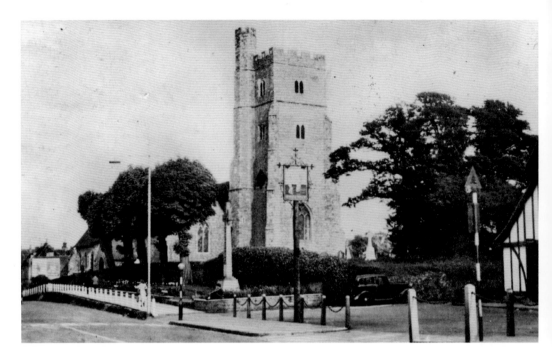

The Heart of Rainham

Two contrasting views of Rainham as it was in the 1950s. I suspect the former is a truer representation of how it really was, with little traffic on the road. Geoffrey John Hall's painting is probably how many of us view the past. In the main road is the familiar green and cream Maidstone & District bus, while waiting to leave Station Road is a brown and cream Chatham Traction Co. bus.

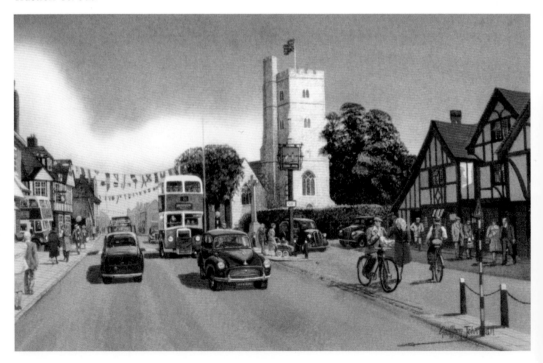

Rainham Pottery and the Tudor Café

Situated just outside Rainham, at the crossroads of Watling Street with Otterham Quay Lane and Meresborough Road, once stood the Tudor café and gift shop, a part of the Rainham Pottery. It is now a used car lot owned by Royden Ltd. Prior to the café opening, this had been the Rainham Pottery works, an offshoot of the Upchurch Pottery works, whose roots date back to Roman times. The Rainham branch was opened by the Wakeley brothers in 1909 and its wares took on the name 'Roeginga Pottery', a name that seems to have been a variant of the Anglo-Saxon word for Rainham. It closed for the duration of the Second World War and did not reopen until 1948. By 1949, its four potters and three female pottery decorators were producing 200 pieces a week, two-thirds of which were exported. It became Rainham Pottery in 1956 when Edward Baker Jnr, its manager, purchased the business for himself, and it manufactured and sold pottery for a further twenty years. Following the construction of the M2 motorway in the early 1960s, which bypassed Rainham, Rainham Pottery lost some of its passing trade. This, and the availability of cheaper, mass-produced ware, became a severe problem for the specialist company, so when Edward Baker Jnr died in 1975, the pottery closed and the site became firstly home to a caravan retailer and later to a used car dealer.

Moor Street

As Watling Street leaves Rainham it takes on a number of different names, one of which is Moor Street. This charming old cottage, probably photographed in the early 1900s, still stands to this day and is still occupied.

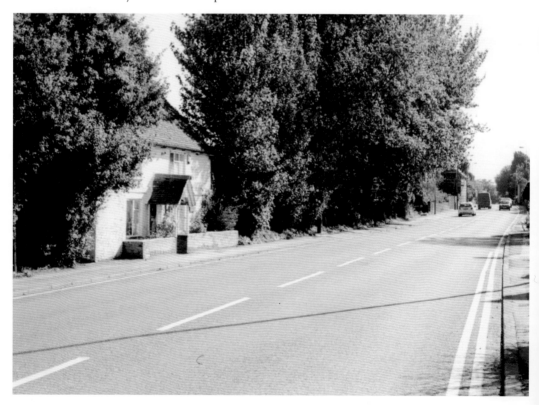

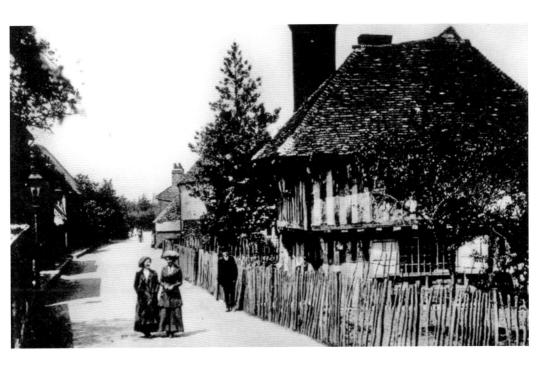

Lower Rainham

Another quaint, old, half-timber cottage, this time on the Lower Road on the banks of the River Medway. This cottage is one of a small group of a similar age, huddled together beside the Three Mariners pub. It is said this is where a young Sir Francis Drake once lived. It is perfectly possible, because his father was the vicar of neighbouring Upchurch.

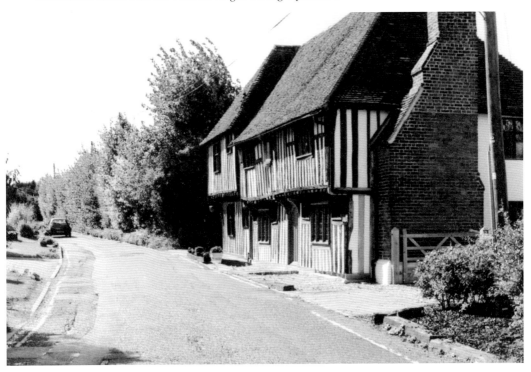

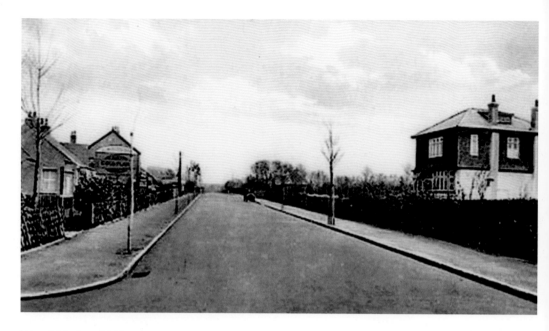

Woodside Road, Wigmore

Wigmore lies to the south of Rainham and estate agents behind the property boom of 1909–11 promised 'sylvan scenery and scent-laden lanes', which was true up to a point, as were the advertisements urging people to 'Live in healthy Wigmore, 300 feet above sea level'. Business was brisk, as dozens of plots were sold off for £10 each, with further £10 quarter-acre plots to the rear of the properties on the Maidstone Road itself. The reality was that the lanes were little more than rutted tracks and most of the buildings, which wiped out long-established cherry and plum orchards, were nothing more than unsightly shacks, raised from the ground on a few bricks. Life in Wigmore in those days was primitive, with no piped water, drainage, sewers, gas or electricity. It was good as a weekend retreat, but definitely not as a main residence. Woodside Road connects Maidstone Road with the M2 motorway link road, Hoath Lane. This view is looking east.

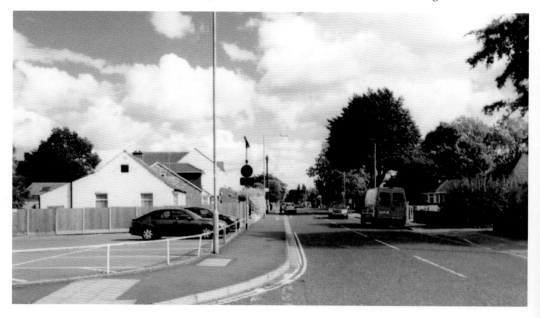

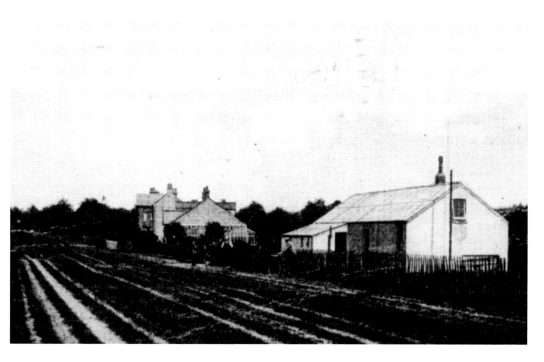

The Smallholders' Club
In 1909, the early 'settlers', many just weekenders, formed a Smallholders' Club, which helped shape the destiny of what was to become Parkwood to the south. Today, the club continues to be a popular social centre for the local residents.

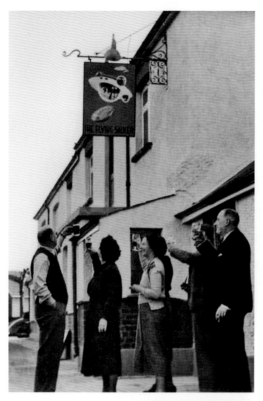

The Flying Saucer Pub, Hempstead

This strangely named pub is another of the many whose licence was transferred from a closed-down pub in Brompton when the Brompton slum clearances took place in the 1930s and 1950s. Large numbers of the Brompton population were rehoused in the newly developing areas of Wigmore and Rainham Mark in the 1930s, and Hempstead and Twydall in the 1950s. The original licence for The Flying Saucer had belonged to the Shipwrights Arms at No. 22 Westcourt Street, Brompton, but on 2 March 1951 the licence was transferred to premises at No. 140 Hempstead Road, Hempstead, which opened under the name of The Flying Saucer. It is said that the building started life as one of the farm buildings from the old farmhouse, which still stands behind the pub, and that prior to becoming a pub it was a shop and a club. It is not known why such an odd name was chosen, but Hempstead is not really an area with an obvious connection to shipwrights – and neither is it to flying saucers! Here we see the landlord and some of his regulars raising a glass to the newly opened pub.

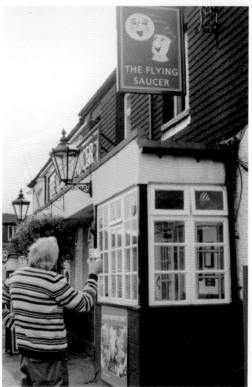

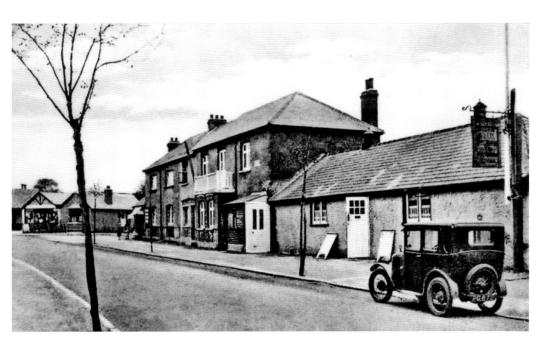

Hempstead

Hempstead is a short distance away from Wigmore but, given today's development of the area, Hempstead, Wigmore and Parkwood have now blurred into one district. Prior to the 1960s, Hempstead was a small and ancient hamlet, with houses clustered around the village centre and small local shops, and a close-knit community. Huge growth has followed since then, with the building of several estates of mostly large detached houses and the Hempstead Valley Shopping Centre, one of the area's first out-of-town shopping centres, which draws people in from much further afield, though in recent years it has faced stiff competition from Bluewater Shopping Centre in Greenhithe and the Dockside Outlet Centre in Chatham. Here we can see the pub building in earlier times when it was a shop and a club.

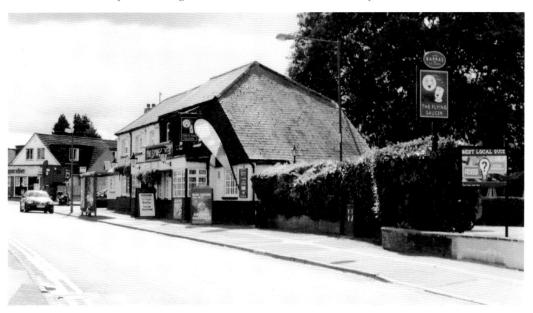

Wigmore Hospital

This photograph shows Hempstead Hill looking towards the site of the old smallpox isolation hospital that was situated off Hoath Lane, Wigmore. It was taken prior to the construction of the A278 link road, which joins the A2 to the M2 and shows how the road split at the bottom of Hempstead Hill near Spekes Road before going on in the direction of Hoath Lane and Woodside as well as towards Darland Banks/Gillingham. The road now only goes to the left towards Darland Banks and the right-hand fork is a tunnel beneath the A278 Hoath Way, nicknamed the Love Tunnel. The buildings above the junction are the smallpox isolation hospital, named in the photograph as Wigmore Hospital.

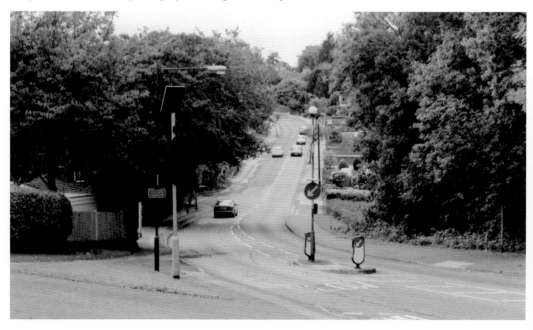

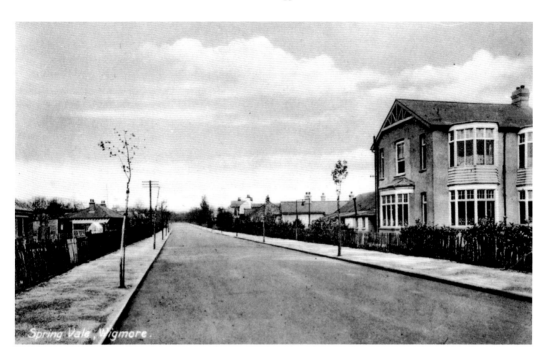

Springvale, Wigmore

Typical of the many roads that were built in Wigmore at this time was Springvale, which was spelt as two separate words when this postcard was published in the early 1900s. Since then it has become just one. To the left of this early view can be seen some small weekend-only bungalows, while to the right is one of the new, much larger houses that were being built here.

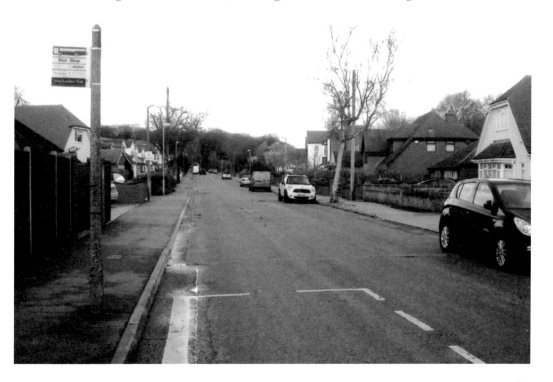

Bredhurst Road, Wigmore
An early view of Bredhurst Road taken in the early 1900s, when Wigmore was starting to be developed.

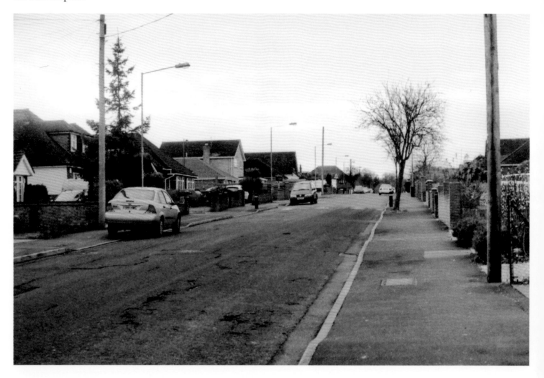

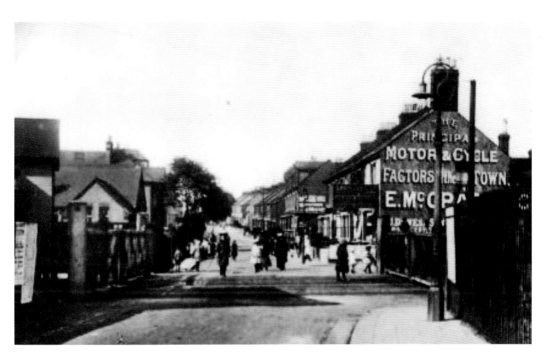

Gillingham Road

When this photograph was taken in 1919, the road was known as Gillingham Avenue. It led from the area now known as Gillingham Green to Livingston Circus, from where it went on to Watling Street by two different routes. This view, looking north, shows the railway crossing, beyond which the Catholic school can be seen on the left-hand side.

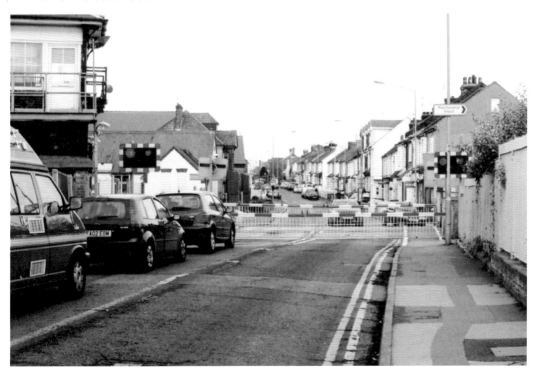

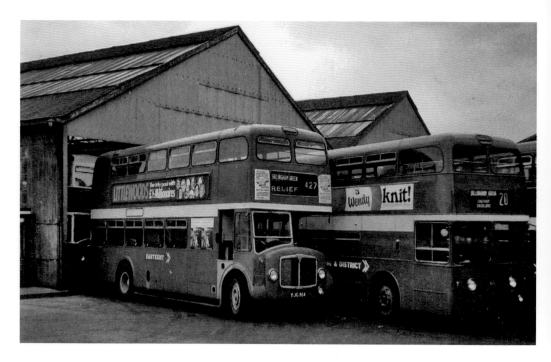

Gillingham Bus Station

Situated in Nelson Road, today the bus station is but a mere shadow of its once busy, bustling former self. During the Second World War it received a direct hit from German bombers – I'm not sure what they thought the site was. There is a colourful local tale (though I'm not sure how true it is) that while the bus station was being bombed, people who could drive grabbed a bus and drove it away from the scene of the bombing. They parked it in a nearby street and rushed back to rescue another. The next morning the bus company officials must have had an almighty task rounding up all the buses without knowing how many had survived and where they all were!

Gillingham Baptist Tabernacle

This Baptist tabernacle was built in Green Street on a piece of land that had formerly been part of Braggs Field, part of Westcourt Farm. A schoolroom was erected at a cost of £700 to the rear of the present site, roughly where the kitchen and storage areas are now. At the western end there was a baptistry and a small gallery, under which was a classroom, also used as a vestry. The pulpit was at the other end near the now disused rear side door. The memorial stone was laid by Miss Dean of Sittingbourne on 21 September 1881, and later relaid by her on 19 July 1888, as can be seen at the front of the present lower hall (the schoolroom). The opening service was held on Tuesday 8 November 1881 and the official opening of the new church, or tabernacle, was held on 30 January 1889. The dedication service was conducted by the pastor, Revd W. W. Blocksidge. The cottages to the right of the main building, seen in the early picture, were demolished in 1900 when an extension scheme was put into operation. This included the purchase of the two houses adjacent to the tabernacle, and the building of additional classrooms on the land at the rear.

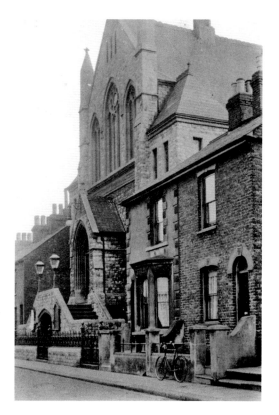

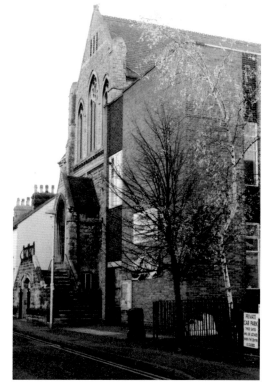

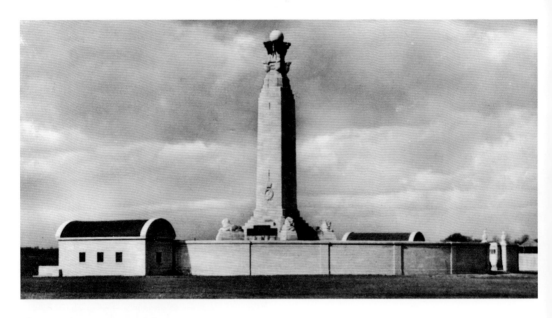

The Royal Navy Memorial

Gillingham is one of three towns to have an identical Royal Navy memorial, the other two being at Portsmouth and Plymouth. Strictly speaking, the memorial belongs to Chatham, but it stands on its boundary with Gillingham. Despite much of the dockyard being in Gillingham, Chatham was a principal manning port of the Royal Navy during the First World War and it was dedicated as the site of one of three memorials to sailors of the Royal Navy killed during the conflict, but who have no grave. The obelisks were designed by Sir Robert Lorimer and the one at Chatham originally contained 8,515 names. Built in 1920, it is made of Portland stone with bronze plaques. After the Second World War and its consequent loss of life, the decision was made to expand the three memorials and each was given a surround designed by Sir Edward Mauf, which contains 10,098 additional names from the later conflict. The surround is also made of Portland stone, with bronze plaques.

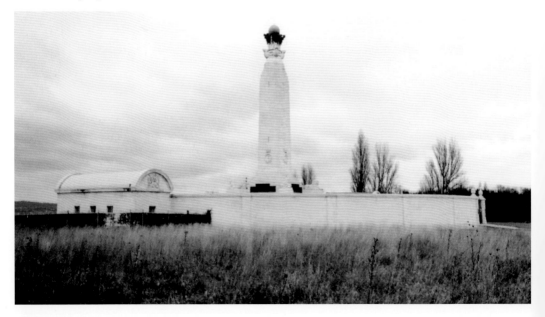

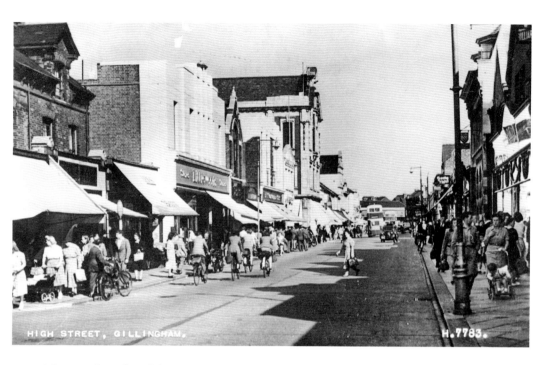

A Last Look at the High Street

To conclude this book, I have decided to take one final look at Gillingham High Street. This is how I, and I suspect many others, will remember it. It is the 1950s, when High Streets were vibrant, busy, bustling places with a mix of local, independent traders and multinational chain stores. How sad and neglected the High Street now looks, with its empty shop units. It has not been quite the same since some of the multinationals defected to the Hempsted Valley shopping centre and the High Street was pedestrianised.

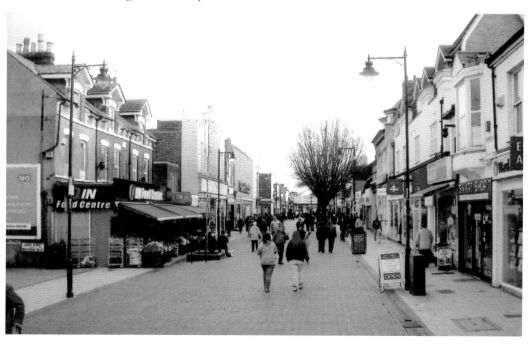

Acknowledgements

I would like to extend my sincere thanks and gratitude to the *Kent Messenger* newspaper for the top image on page 53, and to Barry Kinnersley for supplying many of the pictures used in this book.

The craze for sending picture postcards to friends and family a century and more ago has left us with a rich legacy of a window peering into everyday life as it was then. Every part of a postcard from the picture to the stamp, the postmark, the message it contains and the address is a reminder of a time gone by and is a valuable record of our social history. Postcards have been described as being 'the small change left over from art and poetry, but sometimes this small change suggests the idea of gold'.

Every effort has been made to authenticate the information received from various sources, but sometimes time can play tricks on the memory, so if any part of my text is inaccurate I sincerely apologise and will endeavour to correct it in any future editions of this book. Every reasonable effort has been made to trace and acknowledge the copyright holders of the photographs and illustrations used herein, but should there be any errors or omissions or people whom I could not contact, I will be pleased to insert the appropriate acknowledgement in any future editions.

John Clancy

GILLINGHAM & AROUND THROUGH TIME

Gillingham was once an independent and separate borough with its own character and personality, but in 1998 it lost this separate identity when it joined Chatham, Rochester and Strood to become part of the unitary authority of Medway Council. Today, Gillingham's High Street stretches from the railway station to Medway Park. The original settlement of Gillingham stood on the bank of the River Medway where today there is the Strand leisure park.

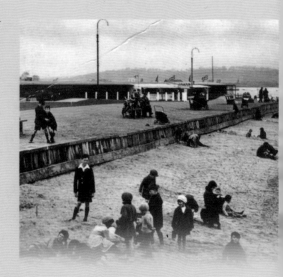

This fascinating selection of photographs traces some of the many ways in which Gillingham and the surrounding areas have changed and developed over the last century

Together with neighbouring Chatham, Gillingham was home for many servicemen and women. The Navy's connection with the River Medway dates back to the sixteenth century and official records show that by 1547 storehouses had been acquired here, marking the establishment of a Royal Dockyard here at Gillingham. Join author John Clancy on a photographic tour of Gillingham and its environs, showcasing the area's many points of interest.

www.amberley-books.com

ISBN 978-1-4456-2288-0

£14.99

AMBERLEY PUBLISHING
The Hill, Stroud, Gloucestershire GL5 4EP

AMBERLEY PUBLISHING